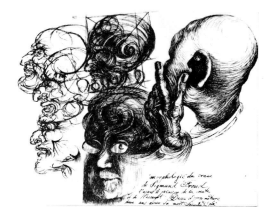

Great Modern Masters

Dalí

General Editor: José Maria Faerna

Translated from the Spanish by Teresa Waldes

ABRAMS/CAMEO

HARRY N. ABRAMS, INC., PUBLISHERS

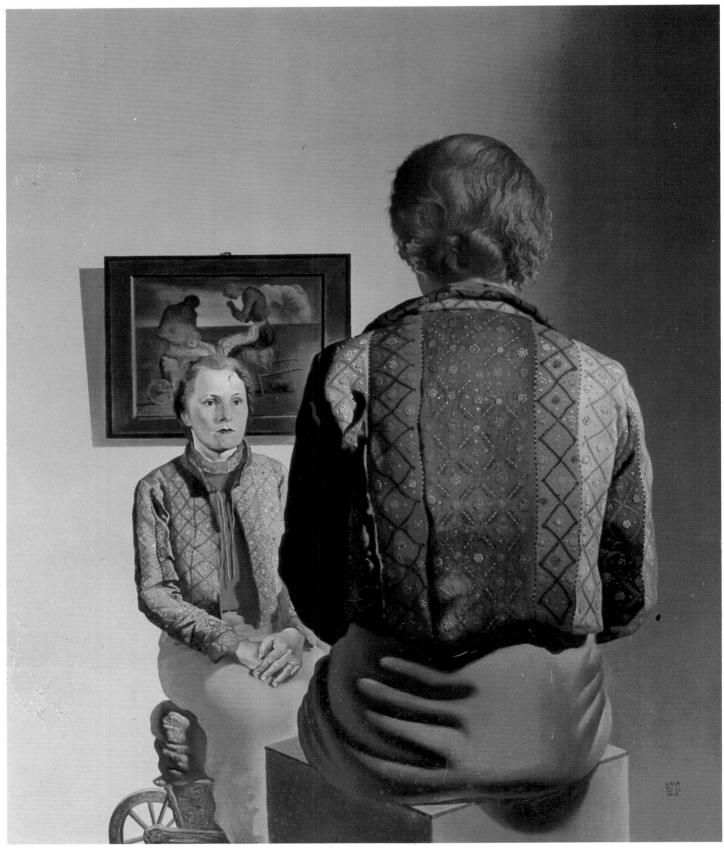

Portrait of Gala *or* Gala's Angelus, *1935.*
Oil on canvas 12¾ × 10½″ (32.4 × 26.7 cm).
The Museum of Modern Art, New York

Dalí and Surrealism

It is not easy to fit the oeuvre of Salvador Dalí into the categories used by modern-art historians. "Avant-garde painting" is a label the artist himself avoided, beginning in the 1940s, when he reclaimed the tradition of the old masters—Jan Vermeer, Michelangelo Buonarroti, Diego Velázquez—so familiar to him. However, Dalí had become well known as a member of the Surrealist movement, in spite of his pronounced individuality. All of his work harks back to that affiliation, even after his official departure from the group in 1939.

Surrealism

Emerging in the early twenties, Surrealism traced its origins to a coterie of Parisian Dadaist poets, whose leader was André Breton. In opposition to the anarchic and destructive impulses harbored by Dadaism, Surrealism introduced positive, alternative artistic practices to replace traditional ones. The Utopian idea of a new man in a new society, common to all avant-garde movements, was at the root of its quest. The Surrealists intended to create this new society by unleashing the universe of impulses and of the unconscious, revealed by Freud's psychoanalytical method. Therefore, dreams and desires were their favorite subject matter. The processes to make them surface, such as automatism—uncontrolled, "automatic writing"—were meant to circumvent the conscious will of the dreamer. This circle of artists came into existence when Breton published the first Surrealist manifesto in 1924.

Cannibalism of Objects, *1937. Ink and gouache on paper, 25 × 19" (63.5 × 48.2 cm). The association of beauty and mortality with food is a constant in Dalí's work.*

Critical Paranoia

Dalí joined the Surrealists in 1929, but by 1922, he had already read *The Interpretation of Dreams* by Sigmund Freud, and had been incorporating material from dreams and the unconscious into his paintings since 1926. The Catalan painter immediately impressed the French Surrealists with his singular way of delving deeply into the group's topics of interest. In opposition to automatism, where the subject is nothing more than a transmitter, a medium for the world of dreams, Dalí proposed to bring order to a state of delirium or hallucination, thus maintaining a dream in force during wakefulness. This is what the painter called the "paranoiac-critical method," further explaining it in many written statements throughout the thirties. Years later, Breton would say: "There had been no revelation like this one since Max Ernst's works of 1923–24 and [Joan] Miró's of 1924. For a while, Dalí conquered everything."

In 1930, Dalí defined the paranoiac-critical method as a "spontaneous system of irrational knowledge based upon the interpretive-critical association of delirious phenomena." He conceived paranoia as a "proud exaltation of the self," a way for the artist to categorize and take possession of his own obsessions with the purpose of organizing them as artistic material. This synthesis, the true essence of Dalí's oeuvre, is reflected in the

An example of a double image: the postcard (above) suggested to Dalí the paranoiac face in the drawing below, where André Breton thought he saw the head of the Marquis de Sade.

5

Study for The Outskirts of the Paranoiac-Critical City, *1935. Ink and pencil on paper, 12¾ × 7⅞" (32.5 × 20 cm).*

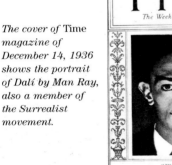

The cover of Time *magazine of December 14, 1936 shows the portrait of Dalí by Man Ray, also a member of the Surrealist movement.*

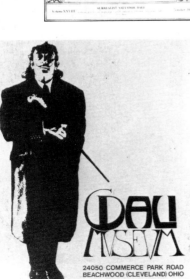

Poster for the Dalí Museum located in Beachwood (Cleveland), Ohio. Collection of Mr. and Mrs. Reynolds Morse.

orthodoxy of his pictorial technique—precise drawing, perfect perspective—that he combined with hallucinogenic themes. Surrealist automatism reveals a different reality, whereas Dalí's paranoiac-critical method explores and reorganizes reality in order to know it better.

If the principal objective of Surrealism is to discredit established reality as an instrument of power and repression, few works can be considered as truly Surrealist as those of Dalí. Underneath the eccentric persona that the Spanish painter constructed for himself, we find an artist of exceptional intelligence and vast worldliness—a man who always saw his painting as a means of broadening knowledge. In that vein we come to understand his interest in science, and the fact that he was the only Surrealist able to impress Freud, whom he met in London in 1932.

Paradoxical Images

Rather than bringing any innovation in pictorial language or mode of representation to painting, Dalí's paradoxical images are his great contribution to the art of our time. It can be said that since he abandoned his attempts at Cubism in 1926, he had recourse only to traditional painting techniques. This tendency became more pronounced during the second half of his career, after the break with Breton and the Surrealists.

Dalí's images are based on paradox; their disquieting character comes through contradiction—hence his taste for double or invisible images, meaning those which can be read in various ways depending on how you look at them. The origin of his symbols can be found in his own life: the rocky landscapes of Cadaqués and the Cape of Creus in coastal Catalonia; the Ampurdán plain; a childhood marked by the premature death of his mother; and in manhood, his idolatrous devotion to Gala.

Ego and Memory

Dalí's egocentricity is not only an extravagant disguise; it is the essential foundation of his paranoiac delirium, the consequence of his continual search into the sources of memory and desire in order to give critical substance to his work. Dreams and obsessions are personal and, in principle, not transferable. They are given a universal value by Dalí, who encrypts them in a code accessible to the public via the paranoiac-critical method, combined with traditional pictorial language. This code is a catalogue of themes that recur throughout his work: the softening of objects through dreams; foodstuffs as a metaphor for mortality; the wheels of memory of the Catalan mystic/poet Raymond Llull; the ambiguous images—death and desire—as two superimposed sides of the same coin.

Dalí's images have had an undeniable impact on the art and culture of our time, from Pop art to films and literature. He is perhaps the modern painter best known to the general public. His work has always been controversial, but the polemic has been mostly centered around his persona. However, his reputation as one of the major artists of our century has gained strength since the end of the 1970s, when a large retrospective was devoted to him by the Centre Pompidou in Paris. The 1994 "Dalí, the Early Years" exhibition at The Metropolitan Museum of Art, New York, once again affirms his place in the ranks of great modern masters.

Salvador Dalí 1904–1989

Dalí's work is permeated by events that shaped his life even before his birth in 1904 in Figueras, Spain. His name, Salvador, had first been given to a brother who died a few years earlier at a young age. Perhaps because of that death, his mother and father, who was a notary, lavished on him an excessive love that fostered his egocentric and flamboyant personality. Furthermore, he saw himself as the phantom of his dead brother, early on becoming familiar with the obsessive idea of death, one of the themes that inspired his work.

Beginnings

Young Salvador started to paint at ten years of age, when he became acquainted with the work of a friend of his family, Ramón Pichot (in Catalan, Pitxot), an artist who was influenced by French Impressionism and Post-Impressionism. An early Dalí work in this book dates from 1920 (*Portrait of Grandmother Anna Sewing*), and shows the Pichot influence while revealing a mastery uncommon for a youngster. Before long, Dalí arrived at the Students' Residence in Madrid in order to study at the School of Fine Arts—from which he wound up being expelled. At the Residence he became friends with Federico García Lorca and Luis Buñuel, young students from the provinces, interested, as was he, in exploring new artistic movements. In those years, Dalí alternately painted landscapes of the Ampurdán plain and Cubist works indebted to Picasso's Mediterranean classicism of the twenties, always displaying the sharp precision in drawing and composition that characterizes his whole career.

Painted Delirium

From the beginning, Dalí expressed himself through painting and writing, continually publishing poems, theoretical musings, and commentaries on his own paintings. Although some of his early writings made allusion to various features of Surrealism and to the famous paranoiac-critical method, the first pictures with a dream atmosphere, already far from Cubism, date from 1926 and 1927 (*Senicitas*, *Blood Is Sweeter than Honey*). By the time he joined the Surrealist circle in Paris, in 1929, his artistic personality was fully mature. During the following ten years, he engaged wholeheartedly in the movement, with the blessing of its supreme leader, André Breton, who wrote the preface to the catalogue of Dalí's first Parisian exhibition in 1929. That same year saw the opening in Paris of Buñuel's film *Un Chien Andalou*, whose script had been developed by Buñuel and Dalí working together in Cadaqués the previous summer.

Dalí contributed articles regularly to *La Révolution Surréaliste* and

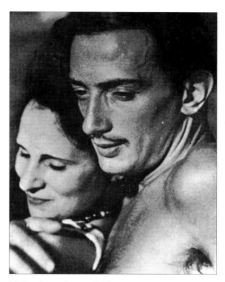

This photo from 1933 will be adapted by Dalí to his painting of the same year entitled Gala with Two Lamb Chops Balanced on Her Shoulder *(see plate 59).*

Rainy Taxi. *Montage presented at the Exposition Internationale du Surréalisme, Paris, 1938. A new version is shown at the Teatro-Museo Dalí in Figueras, Spain.*

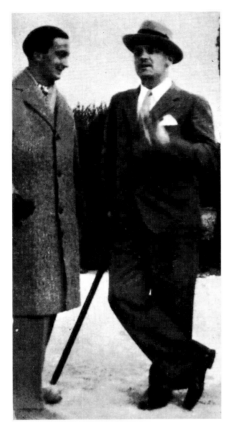

Salvador Dalí and Luis Buñuel at the Cape of Creus, Catalonia, in 1928. That summer they would start writing the script for the film Un Chien Andalou, *completed in Figueras at the beginning of the following year.*

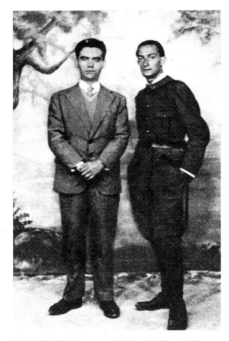

In 1925, Dalí pursued his studies at the School of Fine Arts in Madrid. During the Holy Week recess, he worked with Federico García Lorca, with whom he appears in this photo, designing sets for the play Mariana Pineda.

other official organs of Surrealism during those decisive years in the development of his career. That period also marked the beginning of his relationship with Gala (then still married to the poet Paul Eluard), who became his permanent companion, model, and muse. The liaison with Gala, on top of the revelation that in his Parisian exhibition of 1929 there was a print depicting the Sacred Heart with the legend, in Dalí's handwriting, "Sometimes I spit on my mother's portrait for pleasure," provoked a break with his father, whom he would not see again until 1948.

Dalí's Themes

Many of the themes in Dalí's work surfaced during the thirties: the soft watches (*The Persistence of Memory*, 1931); the double images (*The Invisible Man*, 1929–33); the rotting foodstuffs and organisms (*The Specter of Sex-Appeal*, 1934); the obsession with Jean-François Millet's *The Angelus*. Several theoretical writings definitively shaped the paranoiac-critical method, and Dalí's scandalous reputation was confirmed when French authorities banned *L'Age d'Or*, another film on which he collaborated with Buñuel. The painter was building the flamboyant, theatrical image that made him into a very popular figure, particularly appealing to the press in the United States, where his work had an immediate success, as it had in Europe.

Breton and the Surrealists, committed to the Left in those turbulent years, became ever more uncomfortable with Dalí due to his supposed sympathies for Hitler—which he always denied—and his passion for money—which he never denied. This led to his expulsion from the group in 1939, thus making official a separation that had been presaged since the midthirties, and had only been delayed by Breton's admiration for Dalí's work and his compelling intelligence. From then on, Salvador Dalí became for the Surrealists "Avida Dollars," an ironic anagram of his name coined by Breton himself.

Tradition

Dalí's break with official Surrealism propelled his return to pictorial tradition, without abandoning his characteristic themes. The artist settled down with Gala in Port Lligat, and incorporated religious motifs in his work in several versions of *The Madonna of Port Lligat* and *Christ of Saint John of the Cross*. After the Second World War, he became interested in nuclear physics, which inspired *Leda Atomica* and *The Three Sphinxes of Bikini*. He also designed sets for theater and films and created jewelry and holograms, all the while painting, writing, and promoting himself with inimitable flair and showmanship.

Until Gala's death in 1982, his last years were busy ones, devoted to the Teatro-Museo Dalí (Dalí Theater-Museum, Figueras, Spain), inaugurated in 1974 and conceived as a launchpad to initiate us into Dalí's universe. His last works became ever more focused on the spirit of the old masters. Finally, recognition of Dalí's artistic stature, a subject of polemic throughout his career, seems to have reached unanimity after his death in 1989.

Plates

Childhood Setting

Dalí chose to be a painter at the tender age of ten, when he spent a summer at the Molí de la Torre (the tower mill), a farmhouse near Figueras belonging to the Pichots (also spelled Pitxots), a family of musicians and artists. Thanks to Ramón Pichot, he became familiar with Impressionism and luminous turn-of-the-century French painting. Absorbing those lessons, in the following years Dalí would paint family members—his grandmother and sister—but mostly, the coastal landscapes of Cadaqués and its environs, the setting of his childhood memories, never absent from his painting throughout his long career. In his early work, he alternated among several techniques, reflecting the influence of trends in contemporary Catalan painting. Most noteworthy were his extraordinarily precise renderings, his control over the medium, and the compositional mastery he had already displayed beginning in his adolescence. It is not surprising that in 1925 and 1926, when he was barely in his twenties, the prestigious Galería Dalmau in Barcelona would organize the first two Dalí solo exhibitions.

1 Portrait of Grandmother Anna Sewing, *1920. As a teenager, Dalí already shows his taste for tight and simple compositions in this painting of his grandmother sewing in the family home at Cadaqués.*

2 Self-Portrait of the Artist at His Easel, Cadaqués, *1919. The first known self-portrait by Dalí demonstrates his mastery of lush and impastoed textures, abandoned in his mature paintings in favor of a rigorous and flatter technique that gives more importance to the drawing.*

1

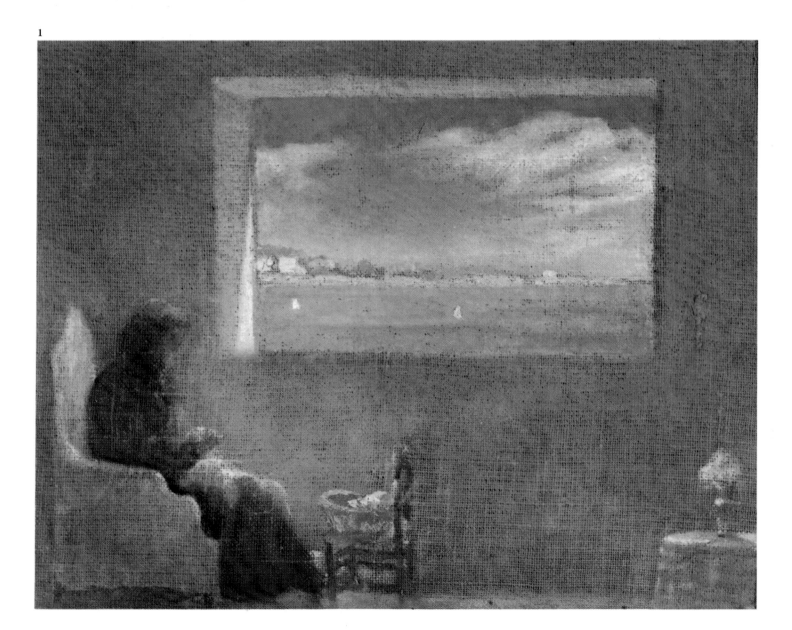

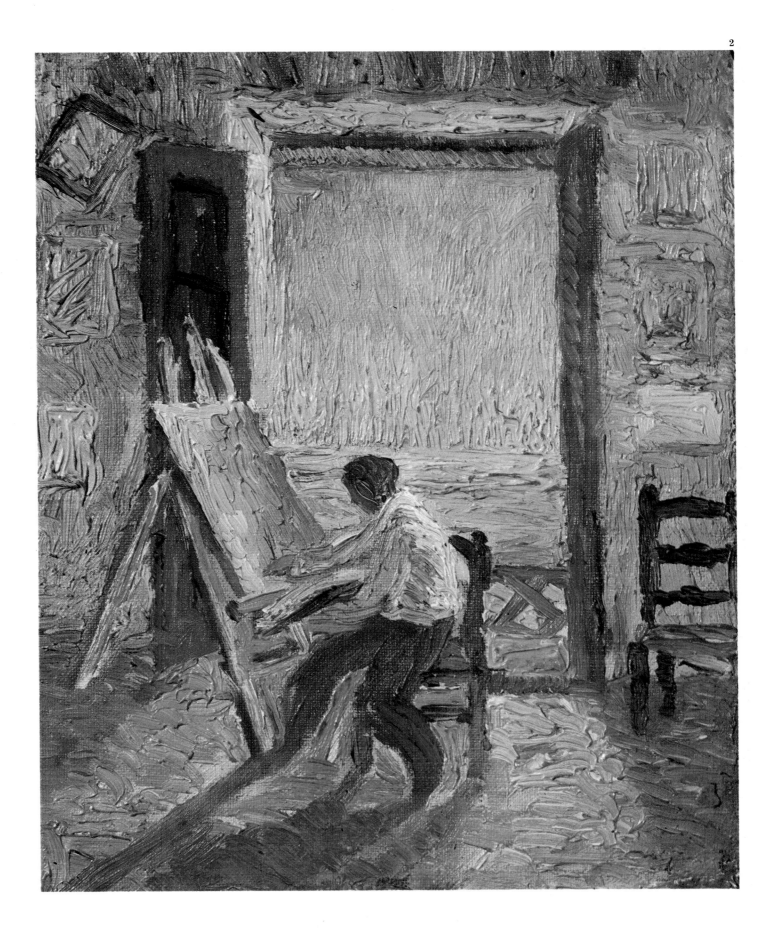

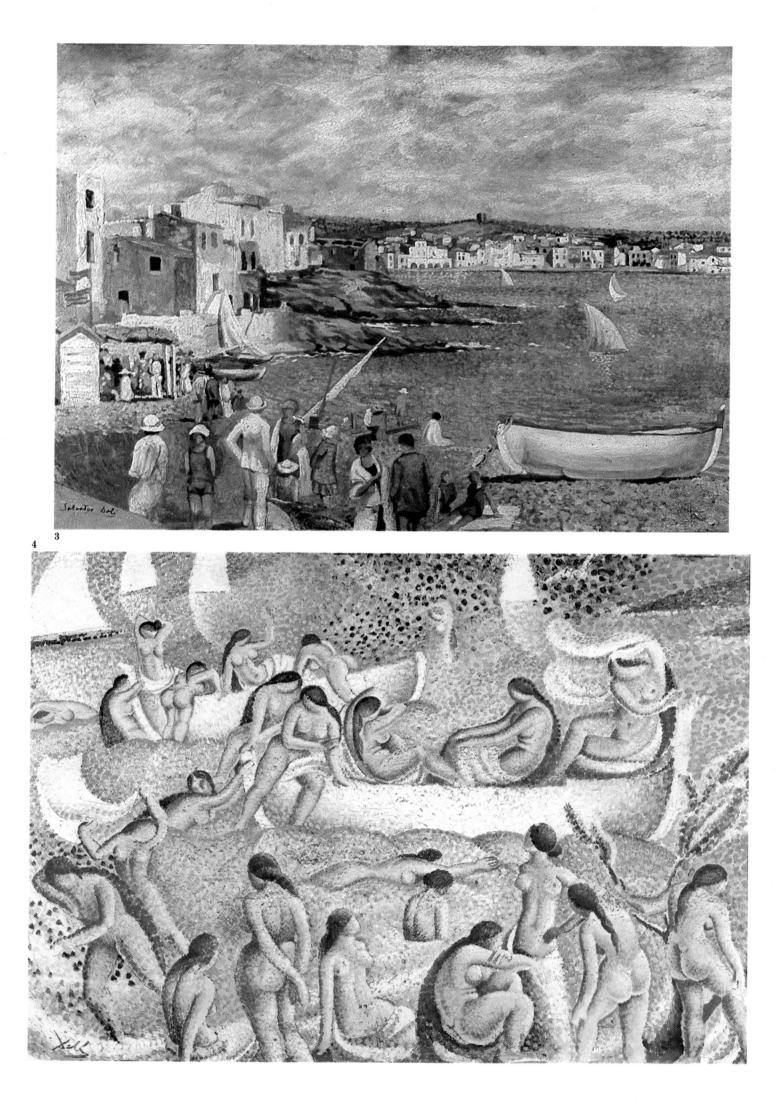

3

4

12

3, 4 The Beach at El Llané at Cadaqués, *1922, and* Bathers at El Llané, *1923. Here are two different ways of looking at El Llané, a cove in Cadaqués near the vacation home of the Dalí family. Both views still reflect the influence of Ramón Pichot, although we recognize in* Bathers *the tendency to classicism in the manner of Pablo Picasso that is prevalent in the first pictures executed by Dalí in a more personal style.*

5 Self-Portrait with Raphaelesque Neck, *1920–21. Dalí copied from Pichot the juxtaposition of orange and violet, two colors he then used very often in his first works. The enigmatic presence of the artist, identifying himself with Raphael in a Symbolist context, is a sign of the profound egocentricity typical of Dalí that would later become the key to his paranoiac method.*

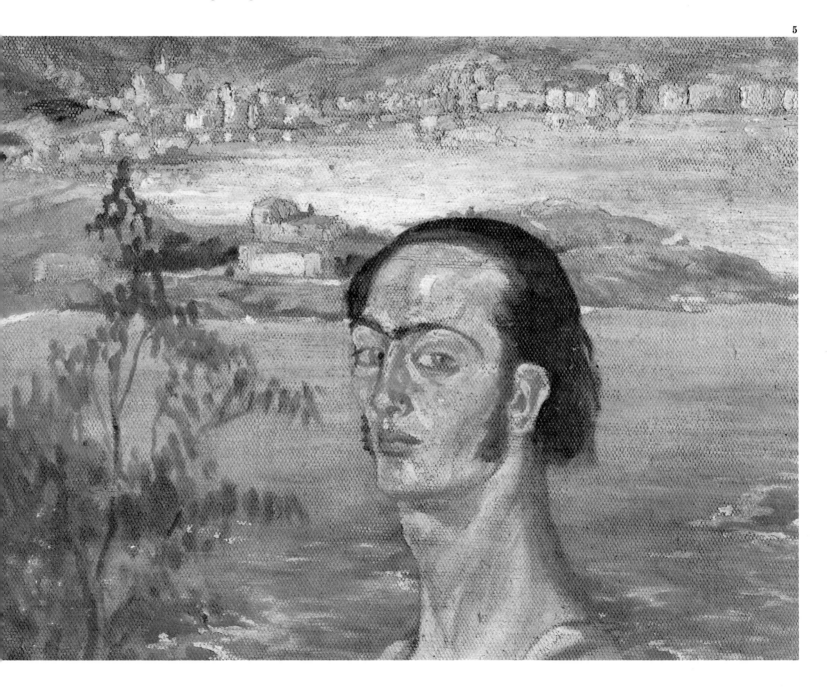

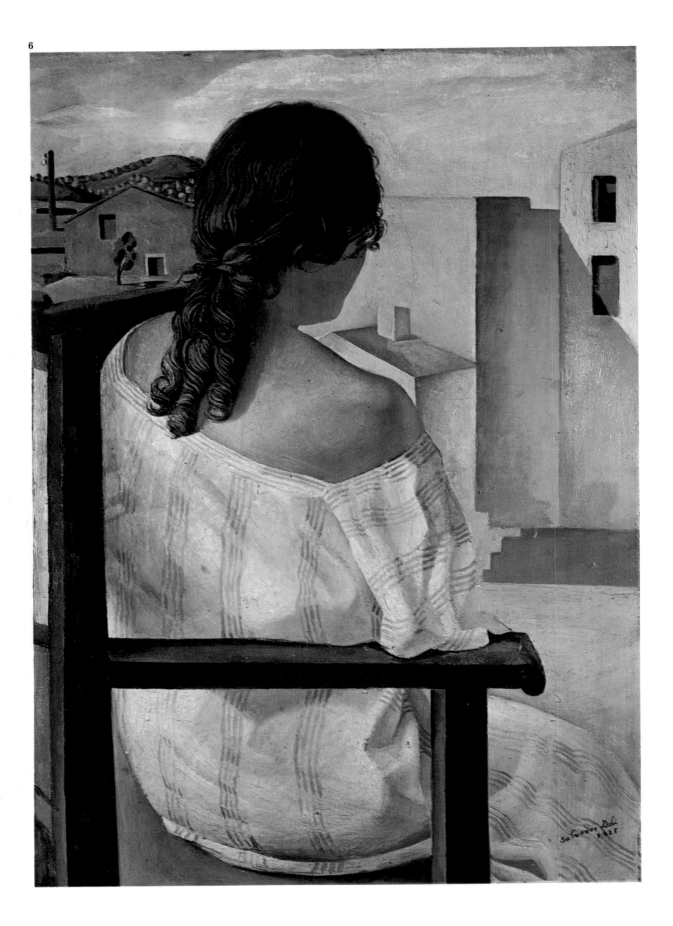

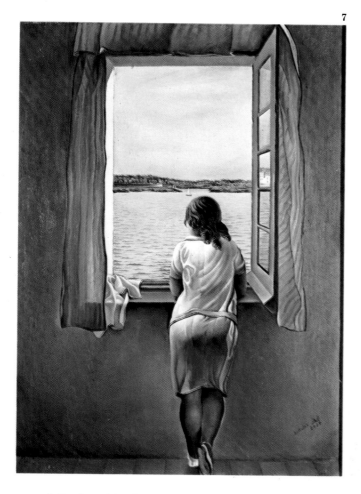

7

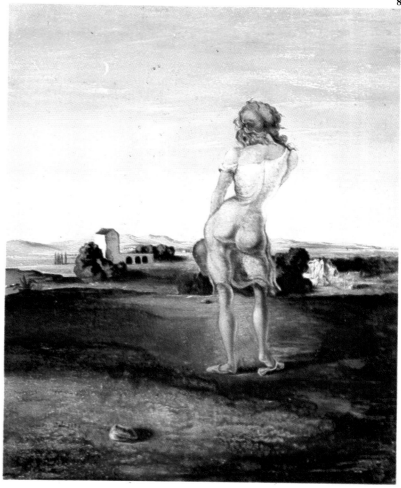

8

9

6, 7 Seated Girl Seen from Behind (Anna Maria), *1925, and* Girl Standing at the Window, *1925. These two portraits of Dalí's sister made a great impression at the exhibition of 1925, which was visited by Picasso. Their rigid images and cool color scheme convey the spirit of what Dalí called "Saintly Objectivity," discussed in some writings of the period. The subject portrayed with her back to the viewer, drawing in his gaze, is taken from the German Romantic painter Caspar David Friedrich; it is a harbinger of the dreams that will be unleashed in the Surrealist pictures just one year later.*

8, 9 The Girl with Curls, *1926, and* Cliff (Figure on the Rocks), *1926. Familiar landscapes that have appeared in Dalí's pictures from the start—the Ampurdán plain or, in this case, Cape Norfeu, near Cadaqués—start during this period to acquire a phantom air, featured from now on in his Surrealist visions.*

The Avant-Garde Temptation

On his arrival in Madrid in 1921, Dalí was well acquainted with the artistic innovations brought about by Cubism and Futurism. Cubism interested him most, especially the paintings of Juan Gris, not surprising in a young painter so concerned in those formative years with technical rigor and discipline. He shared his avant-garde leanings with his friends at the Students' Residence, Luis Buñuel and Federico García Lorca, with whom he would have an intense and turbulent relationship. However, despite his Cubist experiments, Dalí did not abandon the Mediterranean landscape nor a kind of classicism peopled with ponderous figures in a style similar to Picasso's, to whom he paid a respectful visit during his first trip to Paris in 1926.

10 Venus with Cupids, *1925. This scene of indeterminate mythological character belongs to the same Mediterranean classicism practiced in those years by Picasso. Dalí is still feeling his way and alternates this type of picture with Cubist experiments and even with landscapes, which still show echoes of Impressionism.*

11 Cubist Self-Portrait, *1926. Dalí's models remind us of the portraits of art dealers D. H. Kahnweiler and Ambroise Vollard painted by Picasso in 1910.*

10

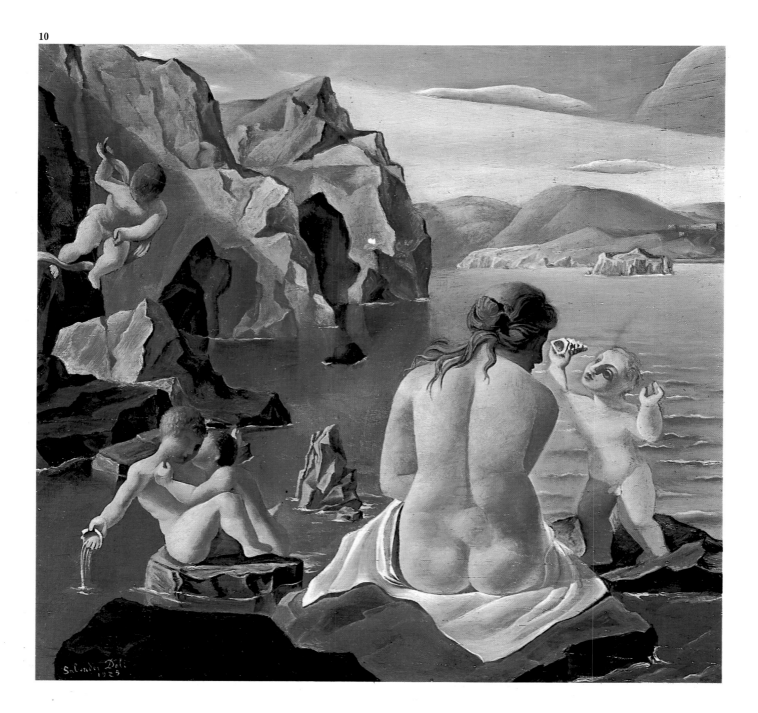

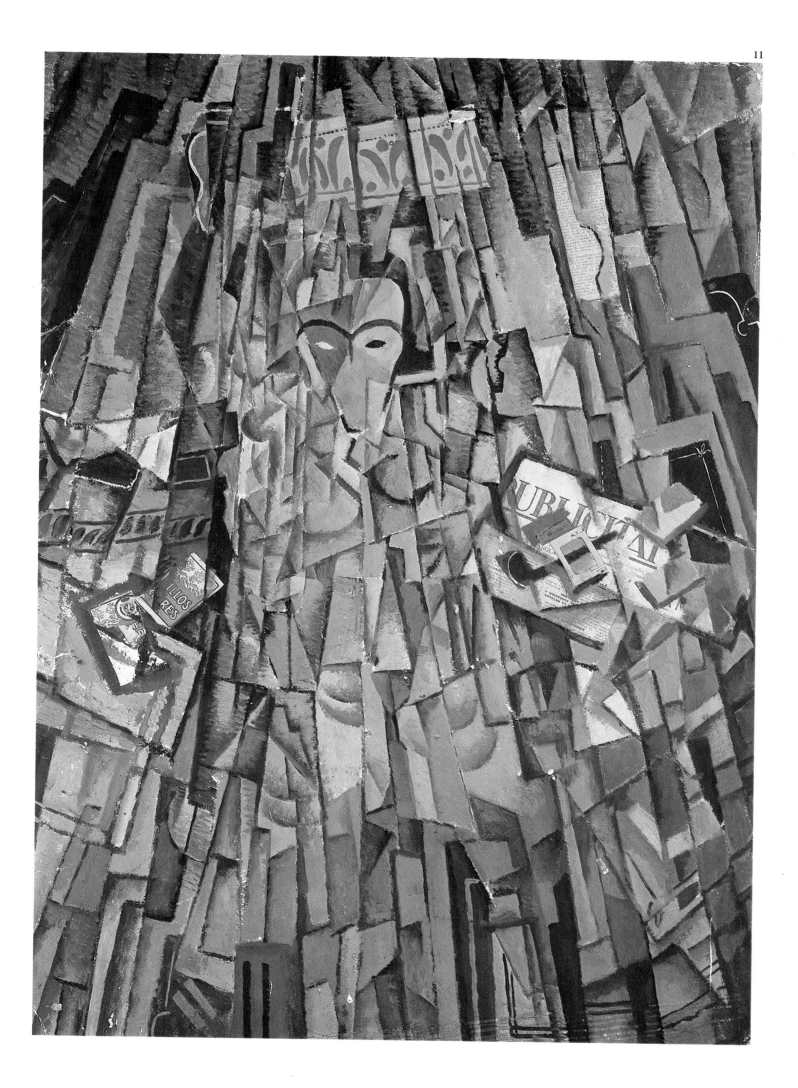

12

13

14

15

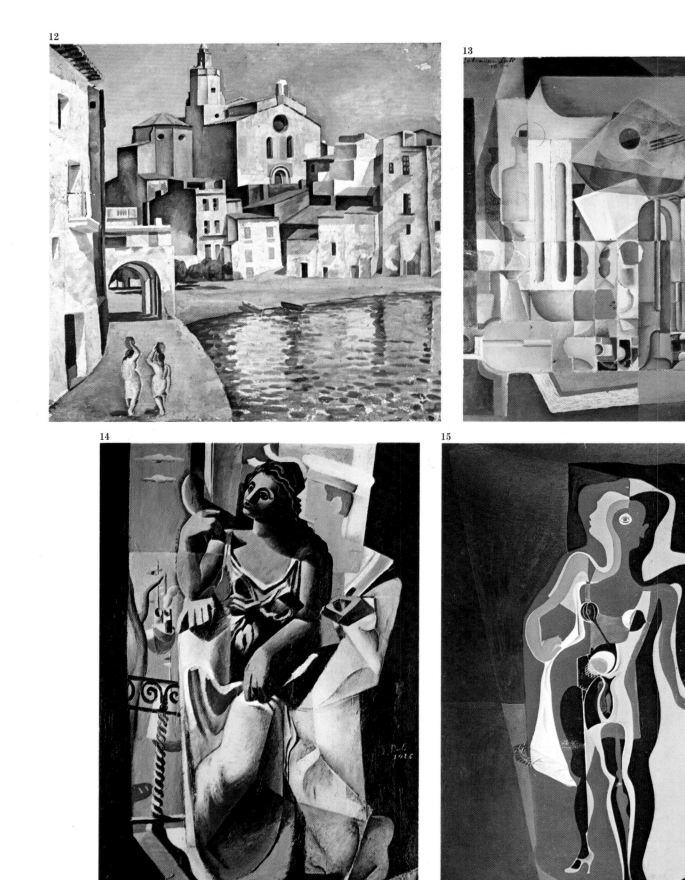

12, 13 Port Alguer, *1924, and* Crystalline Still Life, *1924. The obvious influence of Picasso's work on Dalí can be seen, above all, in his masterly pictorial technique. Order and control in the placement of volume, space, figures, and color are paramount in these compositions, going beyond any sense of one particular style.*

14, 15 Venus and Sailor (Homage to Salvat-Papasseit), *1926, and* Barcelona Mannequin, *1927. Only one year separates these two pictures, where Cubist elements are applied to the human figure. The second one, however, strongly reveals the impact of Surrealism, with its taste for mannequins and machinelike figures inherited from Futurism.*

16 Portrait of the Artist's Father, *1925. "Beautiful forms are vertical planes with curvatures. Beautiful forms are those with firmness and plenitude, where the details do not compromise the appearance of the large masses." Dalí chose this statement by Jean-Auguste-Dominique Ingres to stand next to this work when it was hung in the Galería Dalmau of Barcelona in 1925.*

16

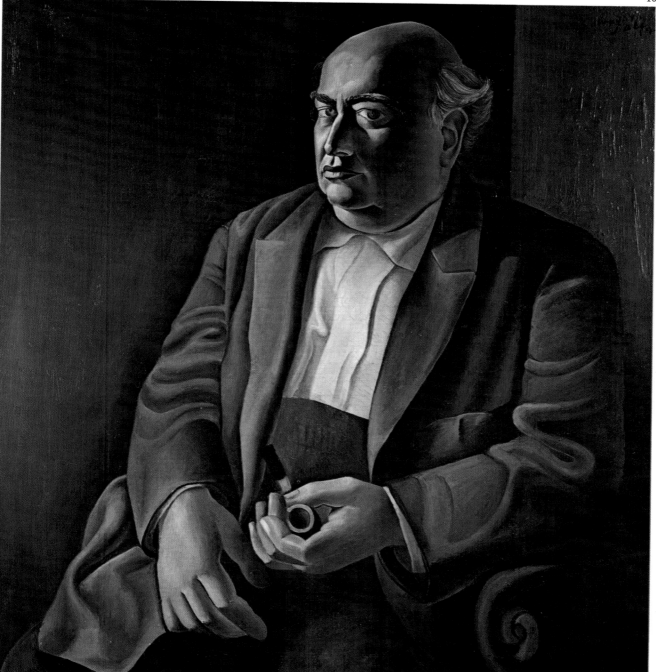

A Harbinger of Surrealism

Although Dalí was not in touch with Breton's group until 1929, his painting had come under the influence of Surrealism some years earlier. Pictures like *Putrefied Donkey, Senicitas,* and *Blood Is Sweeter than Honey* exemplify this tendency—but none more so than *Inaugural Gooseflesh* (plate 18). In all of these, some typical themes—putrefaction, edible objects—are already present, and the influence of Giorgio de Chirico and the Italian painters associated with *Valori Plastici* is palpable. When he joined the Paris Surrealists, Dalí was greeted with respect and admiration, and he immediately became one of the most outstanding artists in the group. His first exhibition in Paris, at the Camille Goemans gallery in 1929, and the opening of *Un Chien Andalou* that same year, marked the beginning of a career whose progress was unstoppable.

17 Still Life by Moonlight, *1927. Dalí still uses a Cubist scenario to introduce elements of Surrealist ancestry, like the head/vase on the table, or the fish, oddly similar to the neck of the guitar. The moon, an image that appears repeatedly in the poetry of Federico García Lorca, seems to be a direct allusion to the writer by means of the feather leading our eye to it through two lines bisecting at a right angle.*

18 Inaugural Gooseflesh, *1928. This is one of Dalí's first fully Surrealist works. The visceral soft shapes, like viscous egg whites, are distributed evenly within a strictly geometric spatial grid conveyed by the dotted lines, the letters, and the numbers. The combination of meticulous draftsmanship applied to fantastic subject matter forms a basic framework for all of Dalí's later work.*

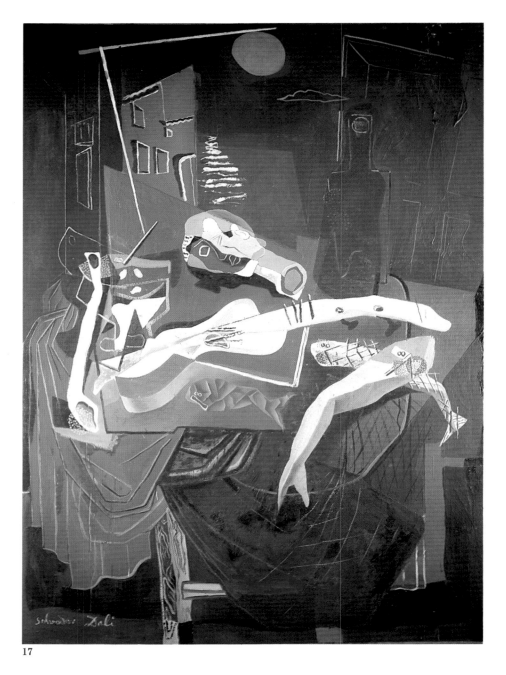

17

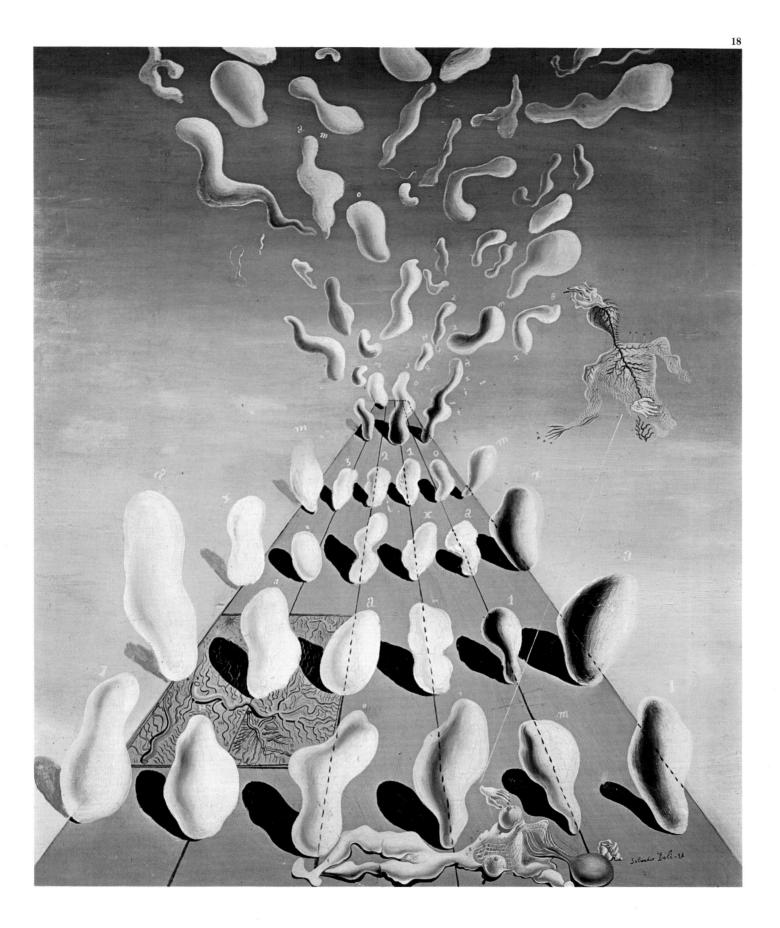

Double Images, Invisible Images

The anamorphosis, or encrypted images that appear only when we concentrate our focus on a picture in a certain way, have been a part of painterly language since the Baroque, serving as a warning against the fallibility of the senses. Dalí makes a favorite theme of this device, which offers at least two possible visual readings of a picture, starting with *The Invisible Man* (plate 20) and using it right up to his later years, as in a 1983 painting, *The Three Glorious Enigmas of Gala*. These are among the most obvious examples of the application of the paranoiac-critical method, which aims to actualize the disquieting images arising from delirium through the possibilities offered by pictorial technique. It is as if there were two pictures mysteriously overlapped into one; the third dimension would spring up from their superimposition as a strange and disturbing relief effect. The painter thus reveals the hidden abilities of the eye at the same time as he demonstrates the unfathomable relativity of the world of images.

19

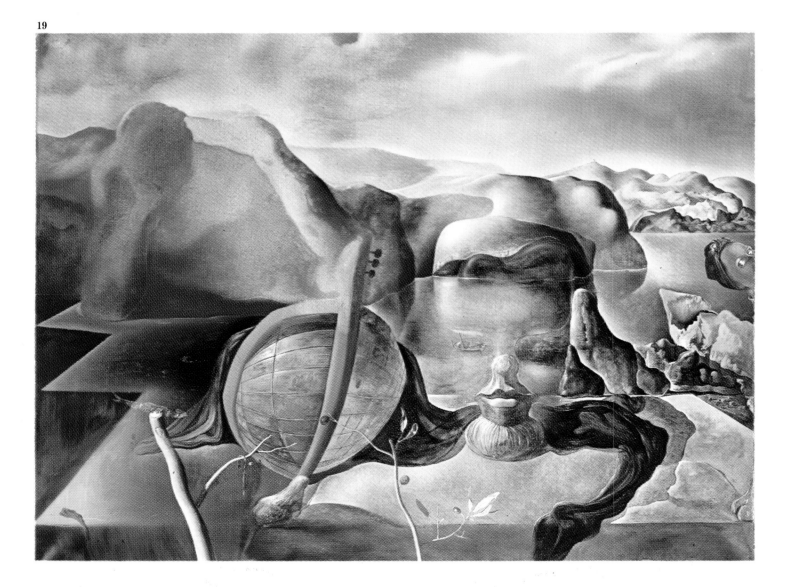

19 The Endless Enigma, *1938. This was the year when Dalí executed several portraits of Freud, and later said that the psychoanalyst's upcoming death was unconsciously fore-shadowed in those works. Here the play of double images is multiplied as in a kaleidoscope. Depending on where our attention is fixed, the picture can be read as a bust of Freud, a still life, a recumbent man, a greyhound, and so on, ad infinitum.*

20 The Invisible Man, *1929–33. Dalí was fascinated by his discovery of the paintings of Giuseppe Arcimboldo, a six-teenth-century Italian Mannerist painter whose com-posed figures are a mélange of various objects. Here, Dalí employs that tech-nique in his first canvas using the theme of the double or invisible image. This picture is par-tially a failed attempt, since he abandoned it without finishing it in 1933, but it is a complete example of the appli-cation of the para-noiac-critical method to the material ema-nating from dreams.*

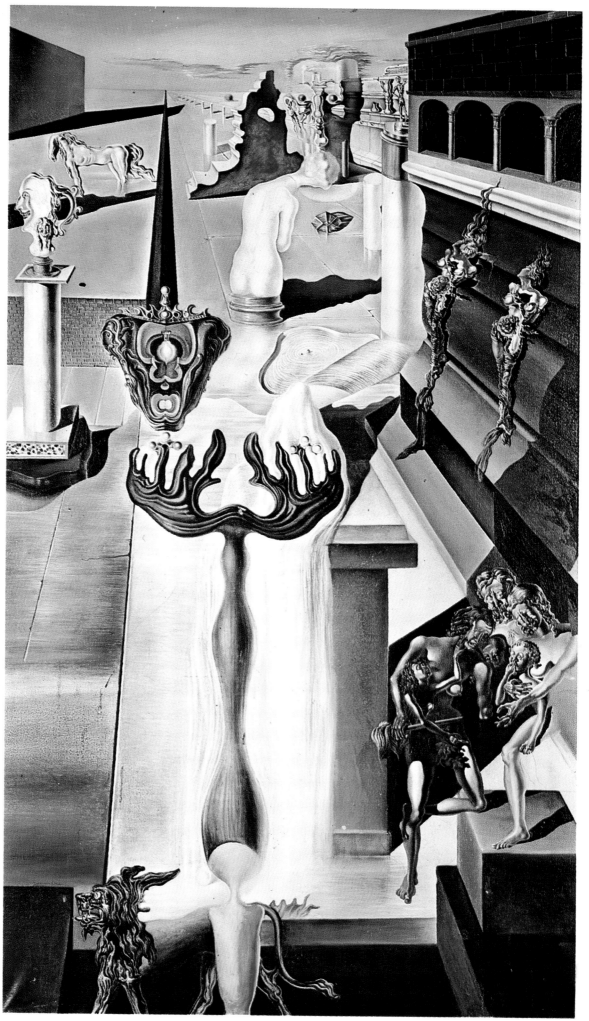

20

The Great Paranoiac, *1936. According to Dalí's explanation, "This face formed with people from the Ampurdán, who are the greatest paranoiacs, was painted after having a conversation about Arcimboldo with José María Sert." The ability of the viewer to see these pictures as double images depends on his "degree of paranoia," meaning his ability to systematically organize the hallucinations produced by dreams.*

21

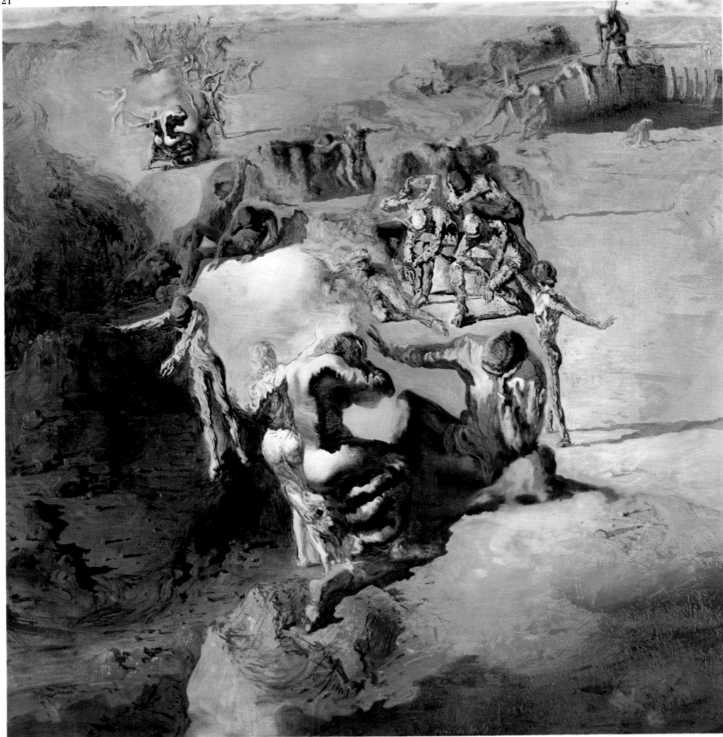

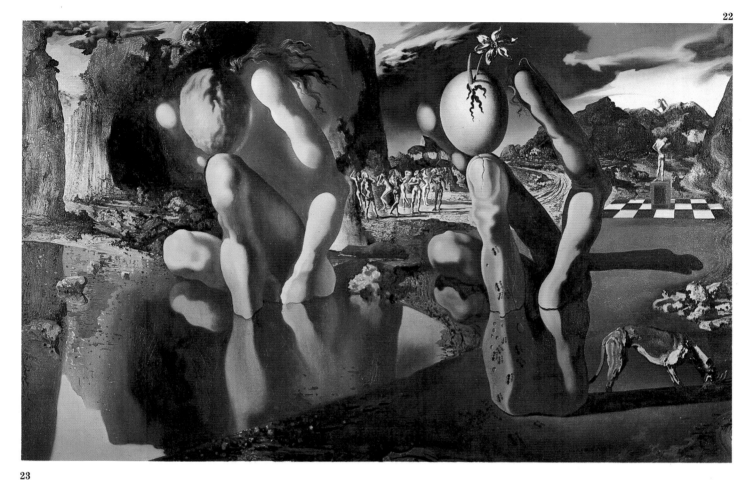

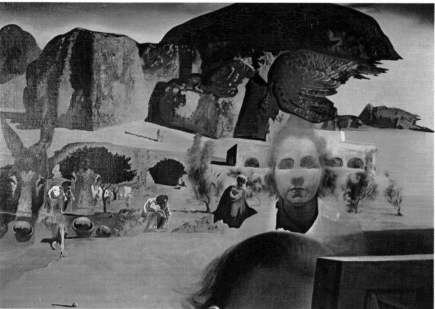

22 Metamorphosis of Narcissus, *1937. The myth of Narcissus was particularly appealing to Dalí, whose narcissism is a key concept for the understanding of his work. Moreover, the confusion between the image reflected on the pond water and the real image, with Death in the background, is almost emblematic of the enigma hidden behind these double images.*

23 Impressions of Africa *(detail), 1938. The title of this picture refers to a play by Raymond Roussel, who had a devoted cult following among the French Dadaists and Surrealists of the twenties.*

24 Salvador Dalí in the Act of Painting Gala in the Apotheosis of the Dollar, in Which One May Also Perceive to the Left Marcel Duchamp Disguised as Louis XIV, Behind a Curtain in the Style of Vermeer, Which Is But the Invisible Though Monumental Face of the Hermes of Praxiteles, *1965. This picture is an ostentatious, tongue-in-cheek rebuttal to the accusation, frequently leveled at Dalí, that he was excessively fond of money. That was the reason why, after his relationship with the Surrealist group finally was broken in 1939, André Breton styled him "Avida Dollars," an anagram of Dalí's name.*

24

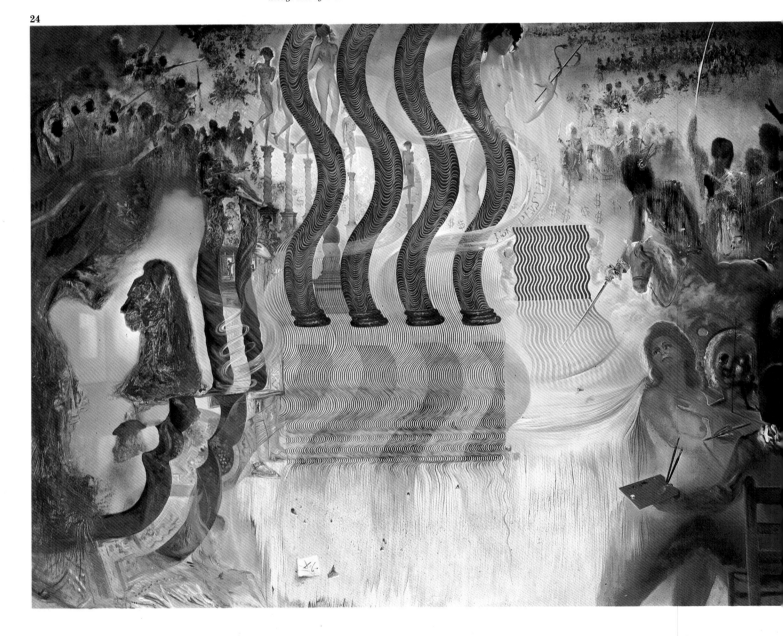

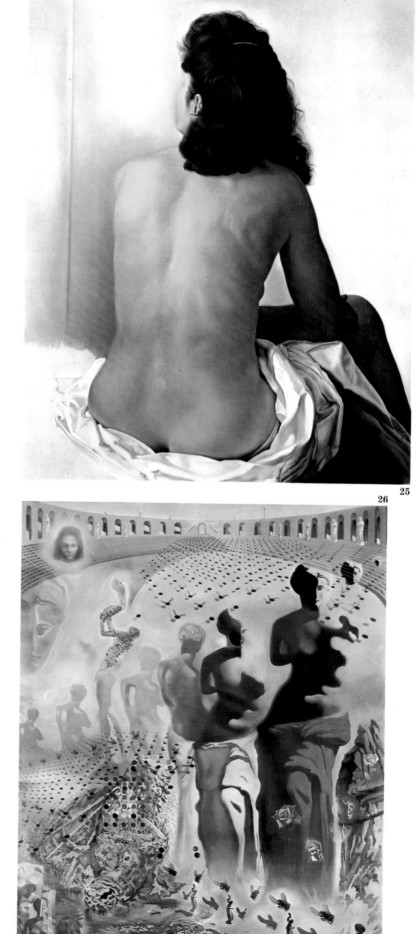

25 Gala Nude from Behind, Looking in an Invisible Mirror, *1960. Here, Dalí recovers the sobriety and evocative power of the youthful portraits of his sister Anna Maria. The indicated existence of a mirror that we cannot see introduces an enigma into the picture: What is Gala contemplating in the mirror? The same subject appeared fifteen years earlier in* My Wife Nude Contemplating Her Own Body Becoming a Staircase, Three Vertebrae of a Celestial Colonnade, and Architecture.

26 Hallucinogenic Toreador, *1969–70. In this intricate work, the sequence of images of the* Venus de Milo *is also a double image of the bullfighter's face; the mantle draped on the statue's legs is also the cape wrapped around the bullfighter's body. The flies, an indicator of putrefaction, suggest death at the same time as they form the toreador's hat. The presence of the boy in a sailor suit in the lower right corner, repeated in so many works, alludes to the perplexed hallucinator.*

25

26

Desolate Dream Landscapes

The first pictures of his youth and adolescence already show Dalí mastering the most difficult technical challenges: impasto, vibrating brushstrokes, layering of paint. He would, however, renounce all that in favor of a tight and flat style, giving primacy to sharp and precise drawing. Such visual precision contrasts with the hallucinatory subject matter, a paradox that Dalí would have learned from the phantasmagoric monumental cities of Giorgio de Chirico—one of the painters most respected by the Surrealists of the twenties and thirties—as well as from his contemplation of the sinuous cliffs of Cadaqués. Those empty landscapes, where an intimation of the horizon menaces the figures, are a favorite scenario for Dalí's delirium, in a sort of funereal transfiguration of the light-filled scenes that appear in his youthful pictures.

27 The First Days of Spring, *1929. This picture contrasts the crystalline clarity of the space, defined by the horizon and two long lines or rails placed in perspective, with many arbitrary images, fruit of childhood dreams. Such contrast leads to the disintegration of both space and figures, with the latter, silhouetted against the background, floating over the landscape.*

28 Vertigo, or Tower of Pleasure, *1930. In one of the best examples of de Chirico's influence, the shadow projected by an enigmatic figure outside the picture is a hovering menace, as is the ball in unstable equilibrium. The couple, emblem of love and death, and the lion's head also appear in* The Great Masturbator *(1929) and other canvases of the same period.*

27

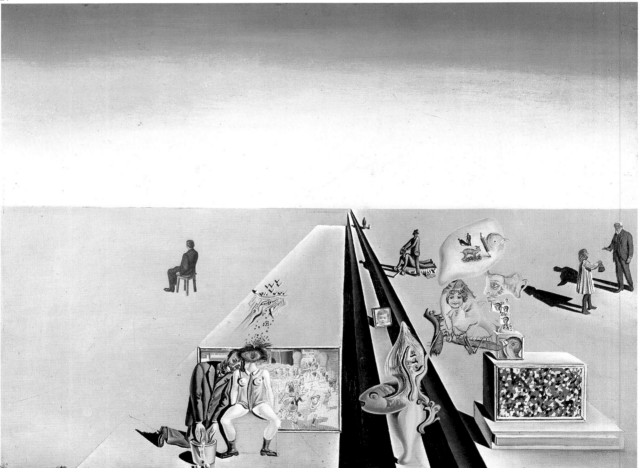

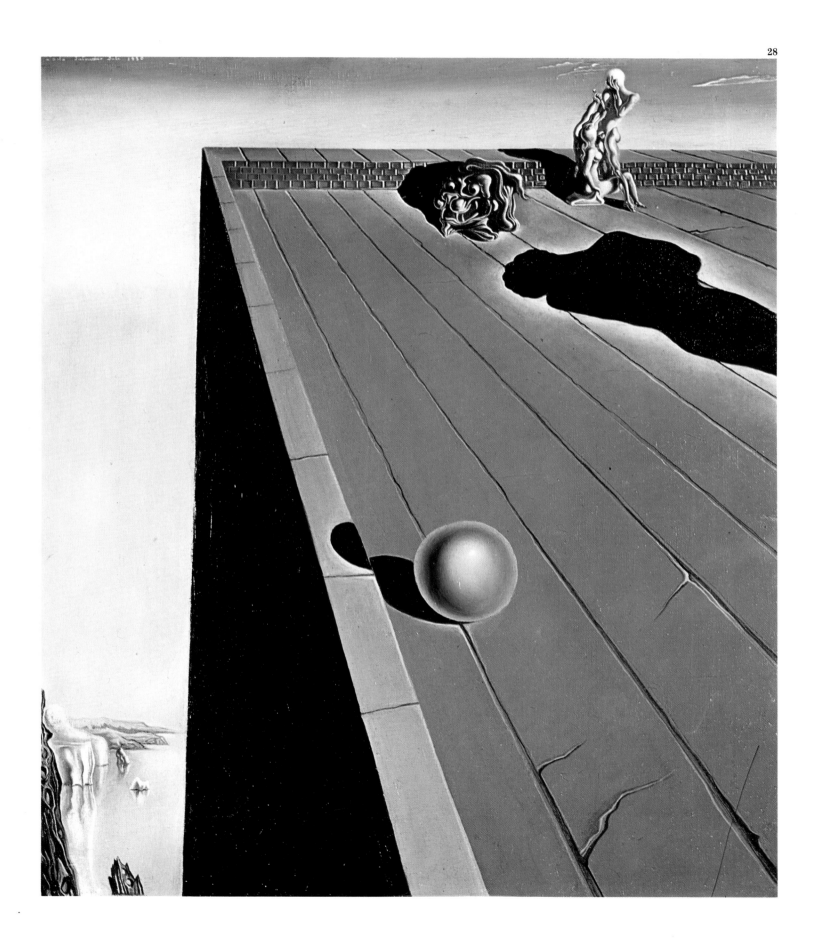

29 Gradiva Finds the Anthropomorphic Ruins, *1931. Petrification is the extreme opposite of the soft-objects theme. Ruins evoking various meanings link Dalí with the sinister and melancholy vein of Northern Romanticism, in the manner of Arnold Böcklin and the Symbolist painters.*

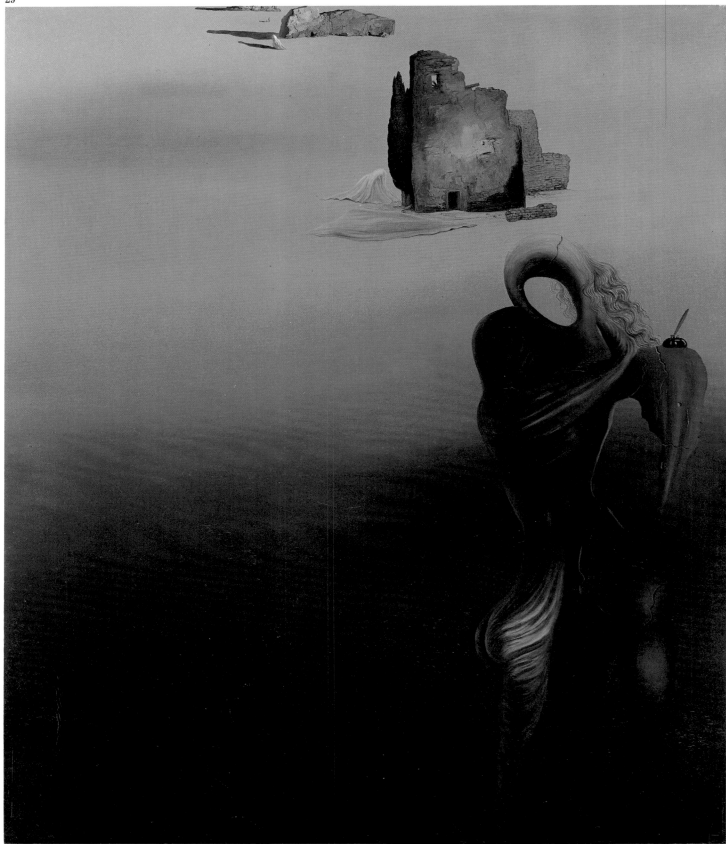

30 Enigmatic Elements in a Landscape, *1934. The painter seated at the easel is Vermeer—whose specter turned into a table appears in another picture of the same year. The tower at the left evokes the Molí de la Torre, a farmhouse belonging to the Pichot family. There Dalí spent a pivotal childhood summer during which he decided to become a painter. The figure of the boy with the hoop appears in other pictures as a stand-in for Dalí himself and as a childish witness to his visions.*

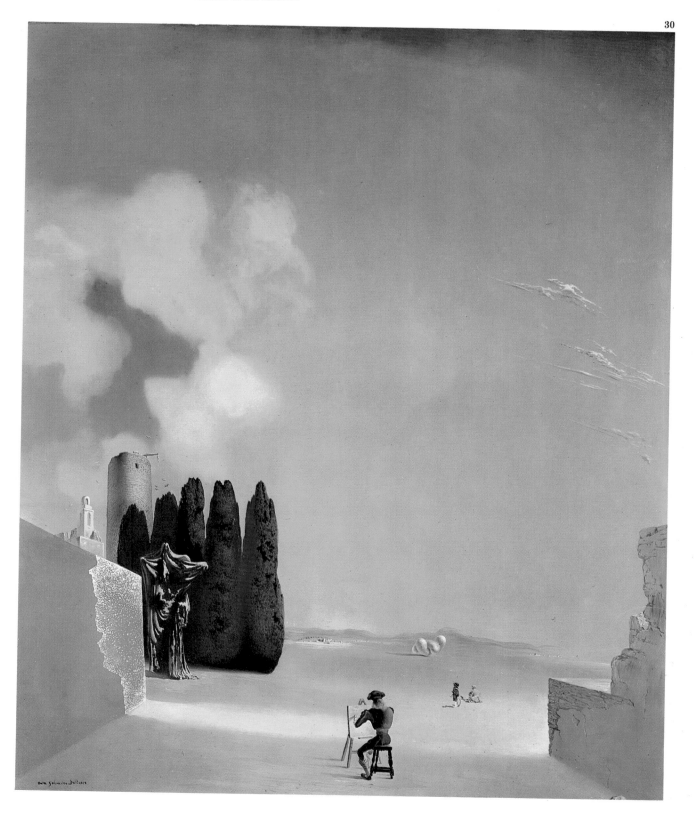

31 Atavistic Vestiges After the Rain, *1934. Found here and in other Dalí dreamscapes, the smooth and compact shapes with cavities are reminiscent of the Cape of Creus. A mysterious tension in the picture comes from the parallel between the form suspended over the crutch and the man with the little boy facing away from us in the foreground.*

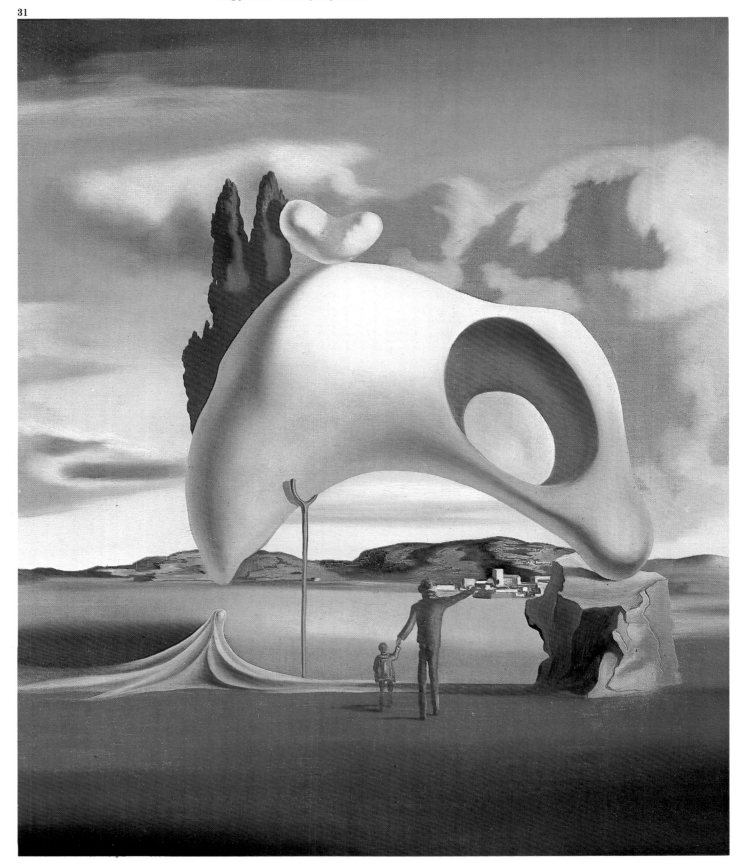

32 The Horseman of Death, *1935. The tower refers once again to the Pichot farmhouse. Petrified cypresses and ruins—part of Dalí's usual pictorial vocabulary in the thirties—serve as a backdrop to the specter of the skeletal knight and his mount.*

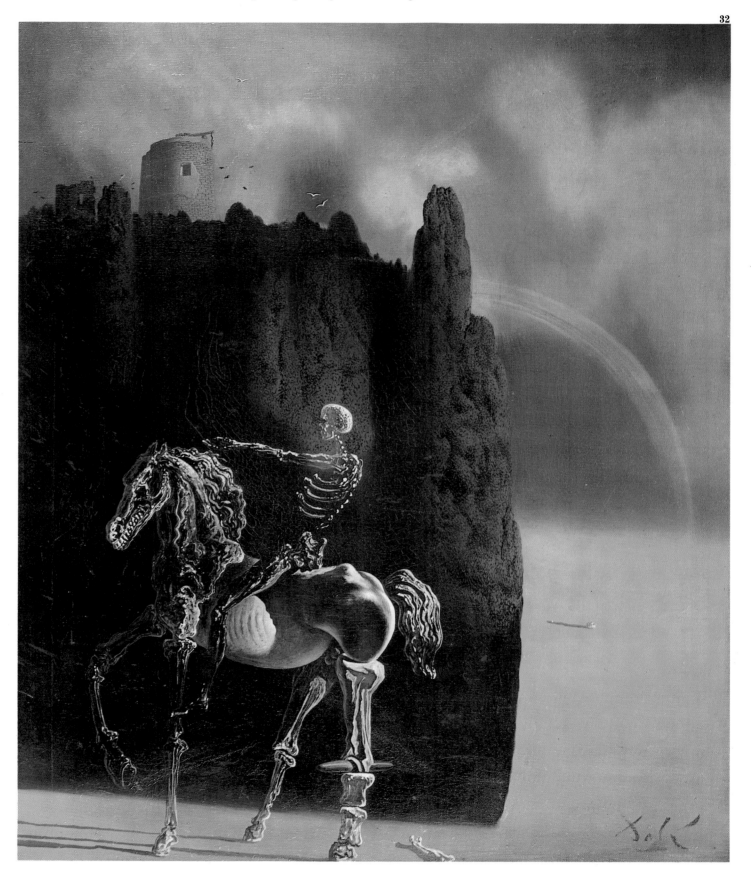

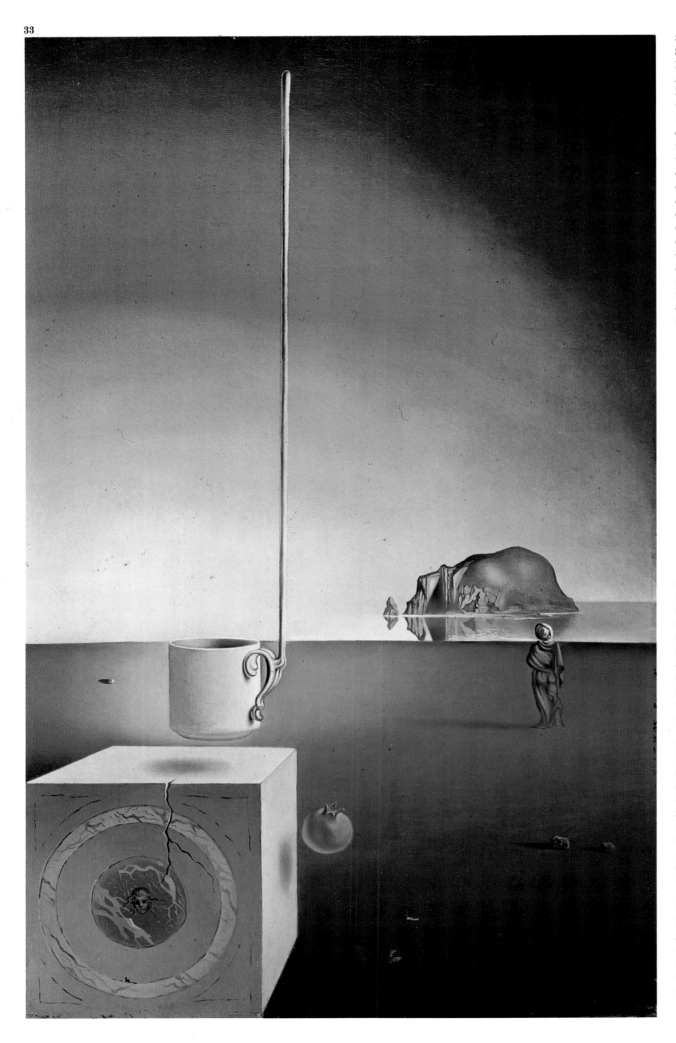

34 Shades of Night Descending, *1931. Dalí again uses the motif, taken from Italian metaphysical painting, of menacing shadows hovering over a desolate landscape, which reminds us once more of the Cape of Creus.*

35 White Calm, *1936. The dreamlike character of this scene comes from its barren landscape—the Bay of Port Lligat—rendered in minutest detail, and the figures, who seem entranced in a pure atmosphere devoid of air.*

36 Landscape of Port Lligat, *1950. The presence of the angel and the spectacular vista imbue this scene with a vaguely disquieting feeling.*

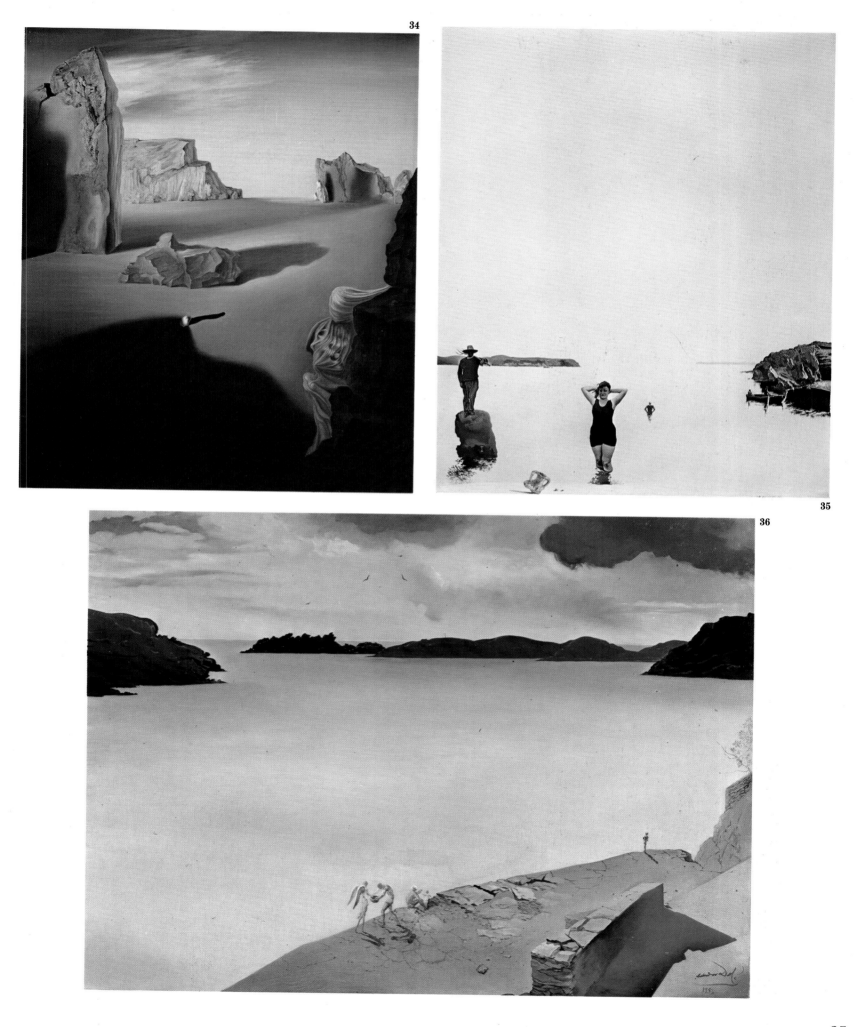

34

35

36

35

Soft Objects

One of the better-known aspects of the paranoiac-critical method is the attribution of properties to objects that are contradictory to the ones they possess in real life. Its most famous example is the representation of soft or melted objects, which become prevalent in Dalí's work beginning with *The Persistence of Memory* (1931) and *Premature Ossification of a Railway Station*. The celebrated soft watches appear for the first time in these pictures. In Dalí's painting, softness can afflict almost any solid object and generally symbolizes its phantom state, a conscious vestige of the world of dreams. In the case of watches, however, the image has deeper implications referring to the relativity of space-time interaction—the so-called fourth dimension. Regardless of particulars, we must not forget that the overall quality of softness represents for Dalí whatever is digestible and nourishing in opposition to what is hard, unfathomable, and ultimately, unknowable.

37 Agnostic Symbol, *1932. The infinite prolongation of the handle of a teaspoon that contains a small object, as if an offering—in this case, a tiny watch—is repeated in other pictures by Dalí. The novelty here lies in the warping of the handle to avoid an enigmatic obstacle.*

38 Premature Ossification of a Railway Station, *1930. One year before* The Persistence of Memory, *a soft watch made its first appearance. The scene's desolation contrasts with the dynamic character associated with a railway station, thus converting it into a metaphysical landscape like the ones that often appear in Dalí's works of the early thirties.*

37

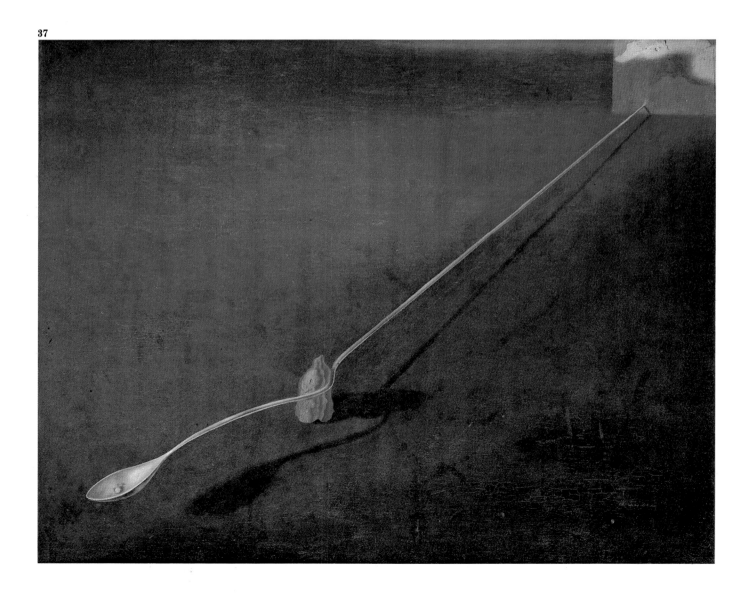

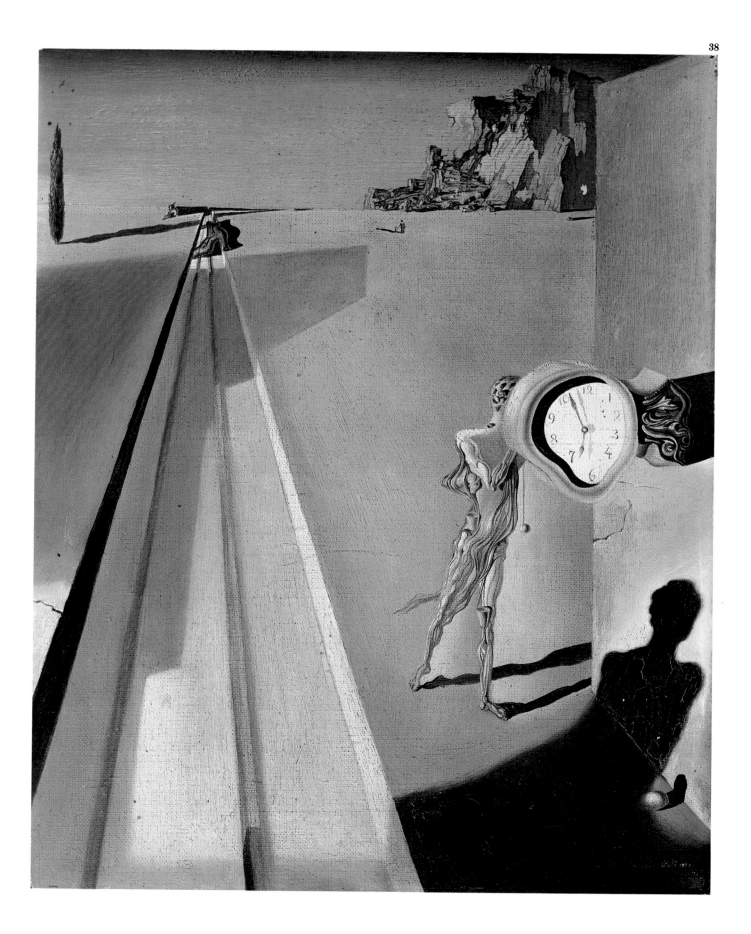

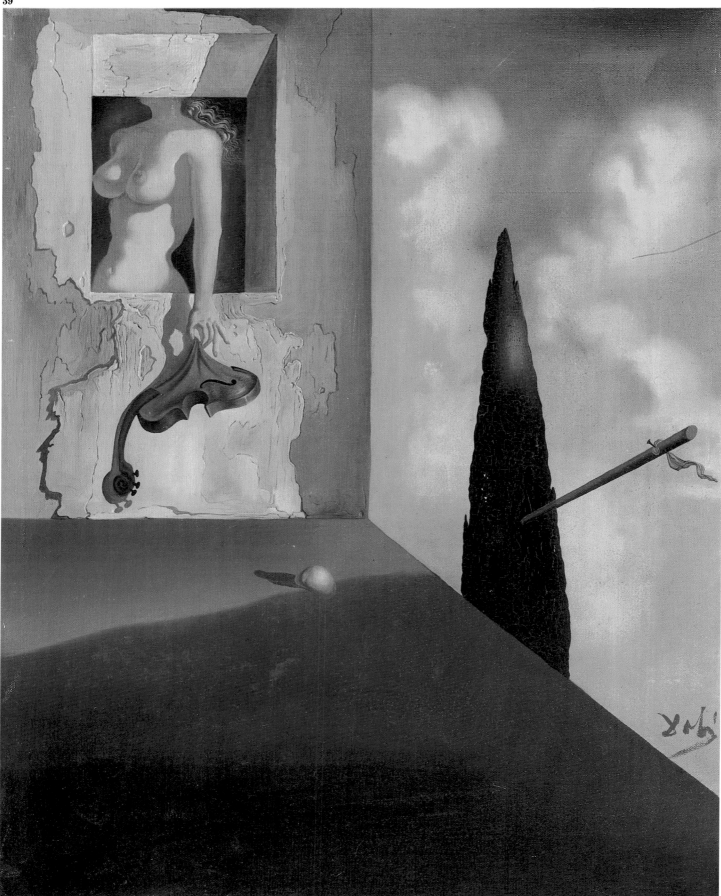

39 Masochistic Instrument, *1933–34.
Softness of objects can allude to their
metamorphosis produced by dreams, or to
their condition of phantoms of real objects,
which makes their normal functioning
impossible. Such is the case here with the
violin, associated through its bow with the
injuring of the wounded cypress tree.*

40 Women with Floral Heads
Encountering the Skin of a Grand Piano on
the Beach, *1936. Women with plantlike
heads, as if made of coral or algae, remind
us here of some figures in the paintings of
Max Ernst. The piano and cello are, as in
the preceding painting, disturbing dream
vestiges of their real presence.*

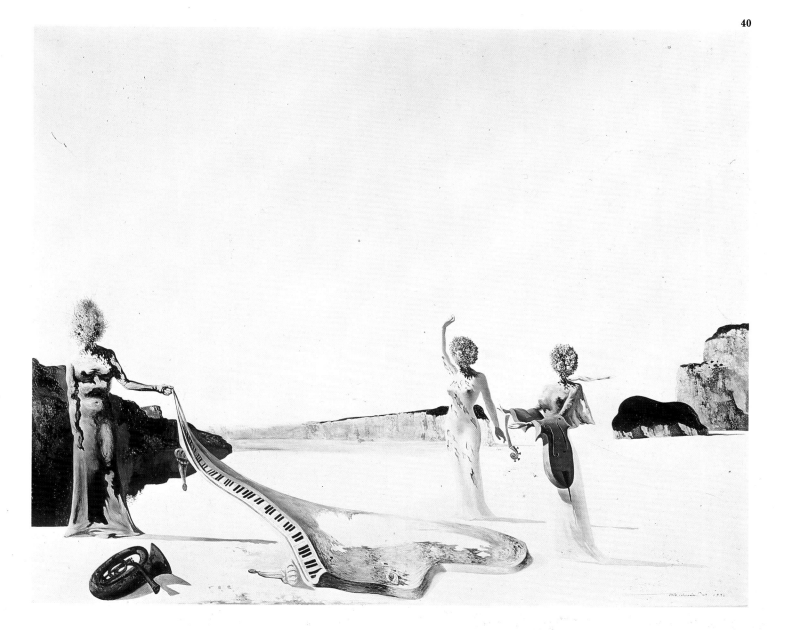

41 Soft Self-Portrait with Rasher of Grilled Bacon, *1941. Raised on its pedestal, this face becomes a fantastic effigy. The rasher of bacon is a reference to culinary tastes in the United States, where Dalí's work enjoyed great success during those years.*

42 Soft Monster in Angelic Landscape, *1977. A striking note here is the contrast between the soft monster—a mutilated face, perhaps also the specter of a shoe or even of a banana peel?—and the hard pedestal on which it sits.*

43 In Search of the Fourth Dimension, *1979. An allusion is made here to Einstein's space/time theories, by means of the wheels next to the cave—both concave and convex—and the sprawling soft watch. The couple with their backs to us are a reference to Plato and Aristotle in* The School of Athens *by Raphael.*

41

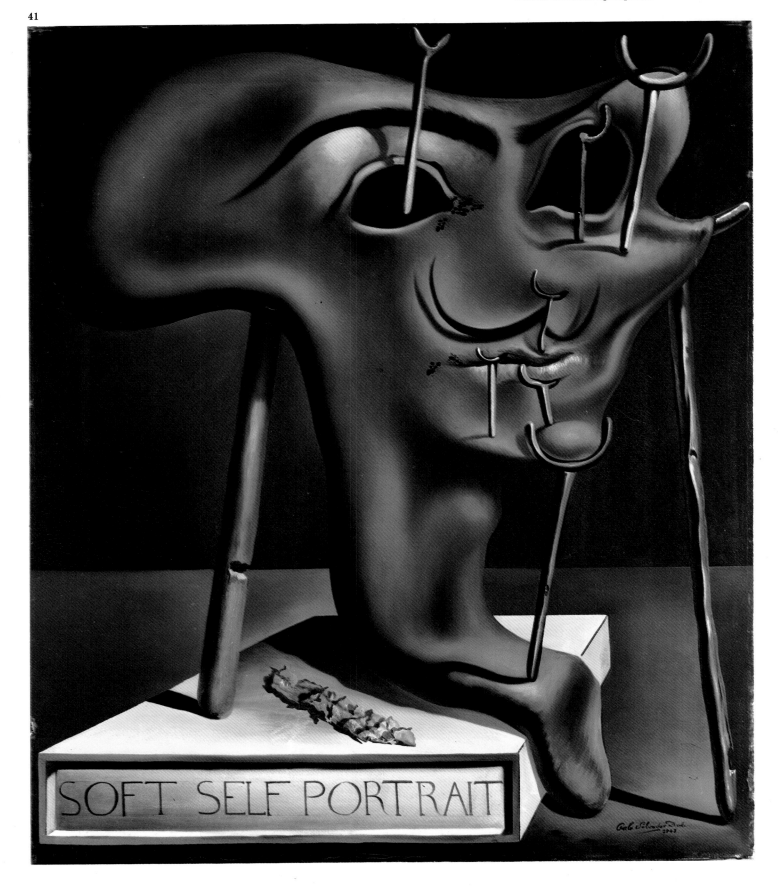

SOFT SELF PORTRAIT

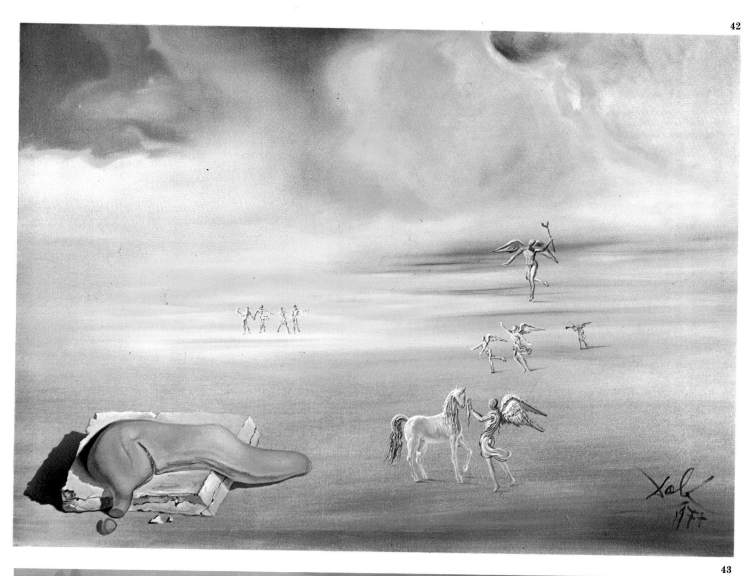

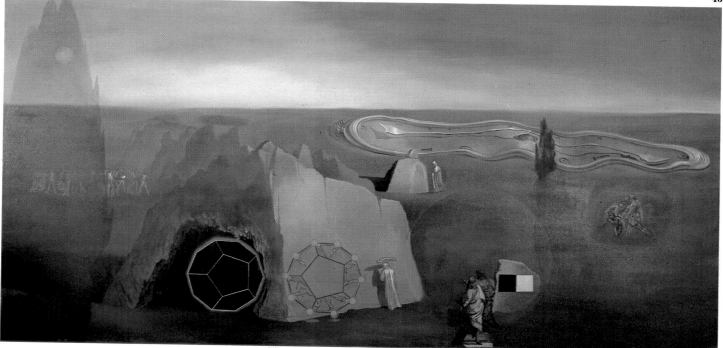

Painted Dreams

Dalí's images seem to emerge from arbitrary associations, although there is always some meaning behind them. Thus, during a painting class at the School of Fine Arts of Madrid in 1926, when the teacher asked students to make a faithful copy of a Gothic Madonna, young Salvador drew a scale copied from a sales catalogue, declaring that it was exactly how he interpreted the assigned model. Later he would explain that he had made an association between the Virgin and the scale in the signs of the Zodiac, a precocious manifestation of "the sudden materialization of the suggested image, the all-powerful fetishistic embodiment of visual phantoms." However, on several occasions Dalí painted dreams almost literally, when they were visions with a more or less identifiable plot remembered by the artist on waking, and painstakingly transferred to canvas. Often the image of a little boy, bearing witness to the vision, appears in those pictures as an allegory of the painter's subconscious memory of dreams reaching back to childhood.

44 Partial Hallucination. Six Apparitions of Lenin on a Piano, *1931. This is a whole catalogue of Dalí's images. Cherries represent "the mystery of bifurcation"; ants crawling on sheet music are a symbol of mortality. Busts of Lenin on the piano come from a twilight hallucination, according to the painter's account, that presented itself to him one morning on waking.*

45 The Specter of Sex-Appeal, *1934. Dalí as a child observes the mutilated body of an old woman, barely able to hold itself together. The upper half is made up of a giant sausage, which represents mortality, as symbolized by the perishable character attributed to all foodstuffs. In Dalí's universe the crutches are sometimes a sublimation of the idea of impotence.*

44

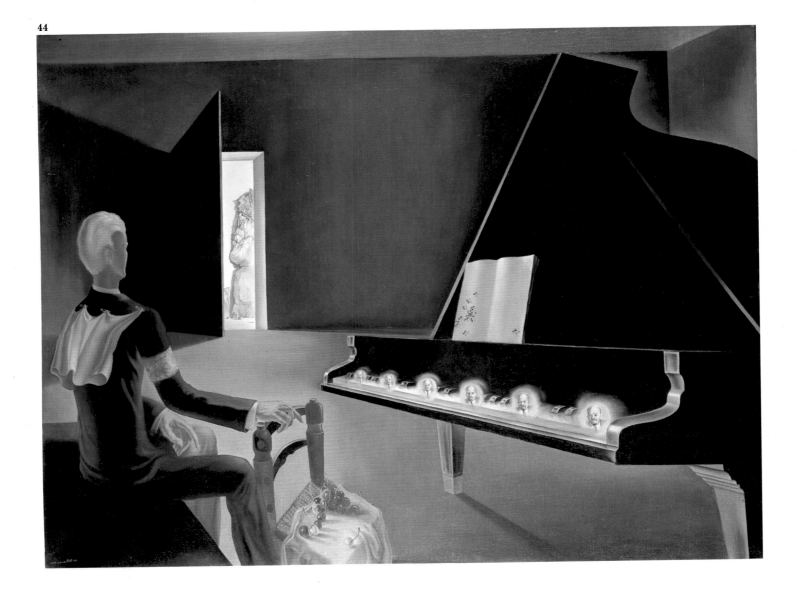

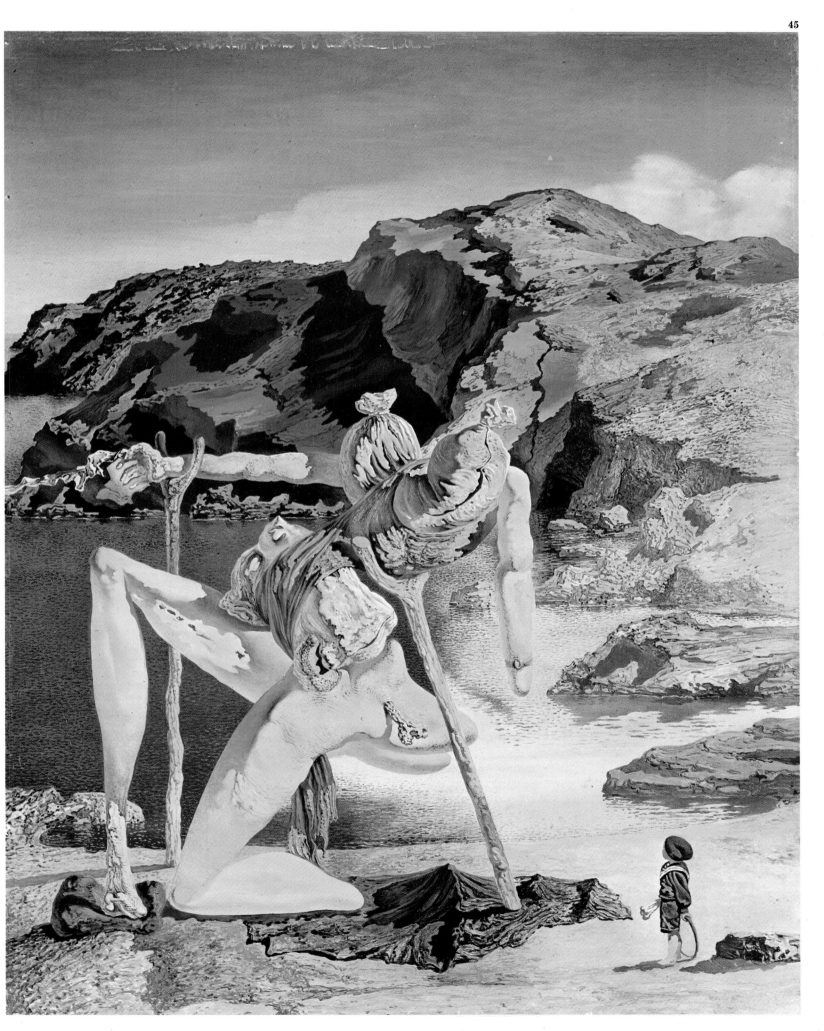

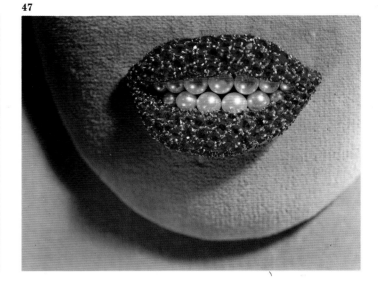

48

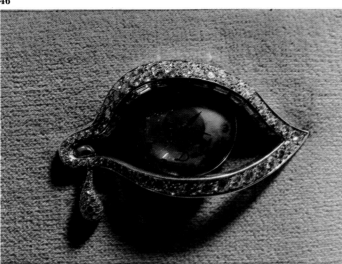

46, 47 The Eye of Time *(watch) and untitled jewel brooch, both with precious stones, 1941. Sight and taste, the two supreme senses in Dalí's oeuvre, are embodied in these two sophisticated pieces of jewelry.*

48 One Second Before Awakening from a Dream Caused by the Flight of a Bee Around a Pomegranate, *1944. The tigers pouncing upon an exquisite dish—Gala—are the image of the bee in the dream; the rifle with bayonet is a clear allusion to the bee's menacing bite. Erotism appears again in Dalí's work as a violent banquet.*

49 Dalí at the Age of Six, When He Thought He Was a Girl, Lifting the Skin of the Water to See the Dog Sleeping in the Shade of the Sea, *1950. Yet another childhood dream set on the beaches of Cadaqués, recreated with disturbing preciseness.*

50 The Enigma of Hitler, *1937. Unfathomable and disturbing, the secretive character of this picture is based on its paradoxical elements: hard and soft, as expressed through the telephone, umbrella, and boiled beans on the plate. The telephone is similar to shellfish in Dalí's pictorial language; in both cases, a hard shell protects the soft matter of the flesh or the words.*

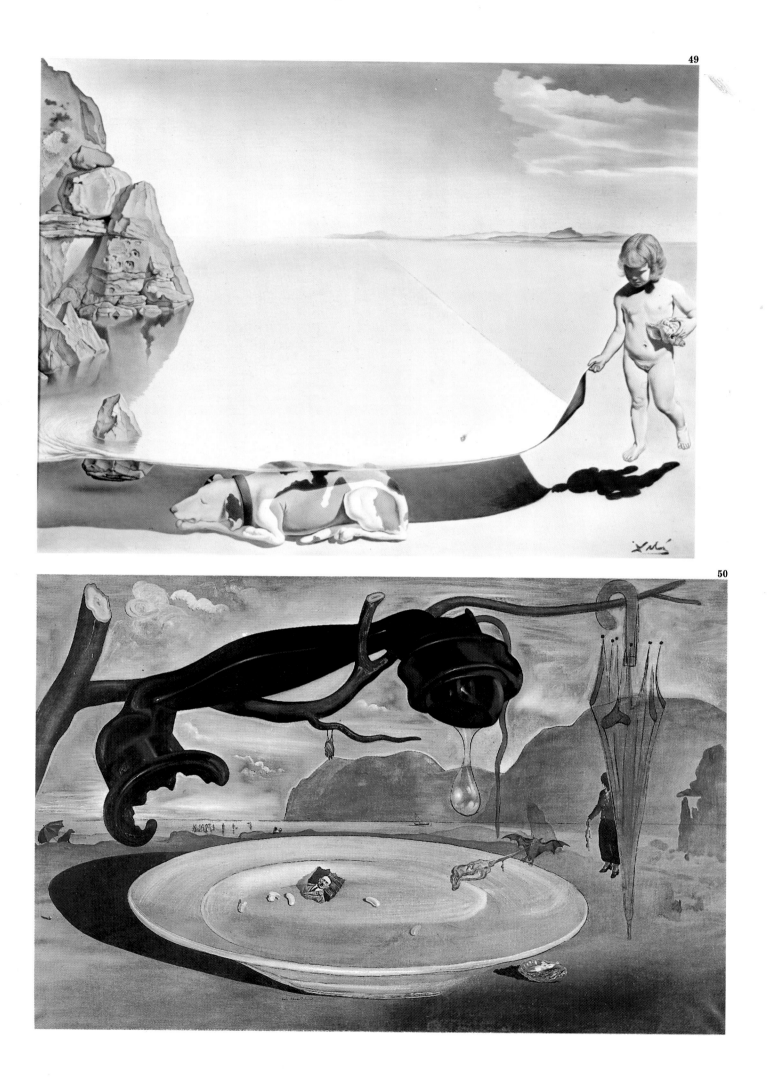

Old Masters

Dalí soon left behind the exploration of modern-art idioms. What interested him above all in Surrealism was the possibility of having access to a new set of themes, like the world of dreams and desires. But as far as applied technique, he remained faithful to the teachings of the old masters, with whose tradition he always wanted to be linked. In the thirties, he displayed an obsession with *The Angelus*, by Jean-François Millet— a realist nineteenth-century French painter who depicted a devout farm couple interrupting their labors at midday in order to pray. During this period, his interest also focused on other nineteenth-century masters who were ignored by the avant-garde, namely, Jean-Louis Meissonier and Fortuny y Carbó. Beginning in the forties, his references to great classics of painting became more numerous: from Piero della Francesca, Vermeer, and Velázquez to his fascination with Michelangelo's *Pietà*, which dominates a sizable part of his later output.

51 Gala and the Angelus of Millet Preceding the Imminent Arrival of the Conical Anamorphoses, *1933. In 1935, Dalí published* The Tragic Myth of Millet's Angelus, *giving free rein to his obsessive interest in this picture. Under its innocent appearance he thought he saw a manifesto of the relationship between love and death.*

52 Millet's Architectural Angelus, *1933. The two shapes in the foreground allude to the couple in Millet's painting (hanging over the doorway in plate 51). The sting wounding the object to the left is a reference to the praying mantis, whose female kills the male after coupling, one of the myths that Dalí associates with this work.*

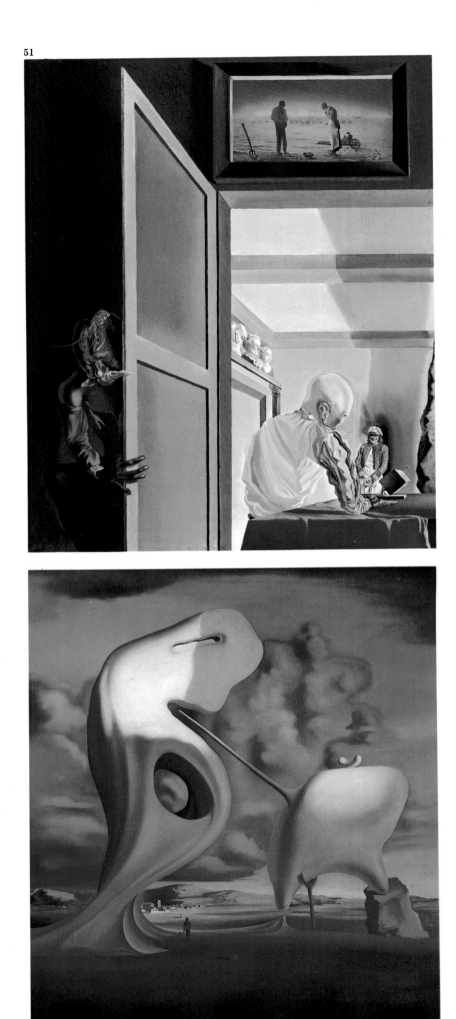

53 The Madonna of Port Lligat *(first version), 1949. Religious subjects make their appearance in Dalí's work of the forties and fifties. The painter projects on them his well-known panoply of themes, without renouncing references to the old masters, in this case, the* Madonna and Child with Angels *by Piero della Francesca.*

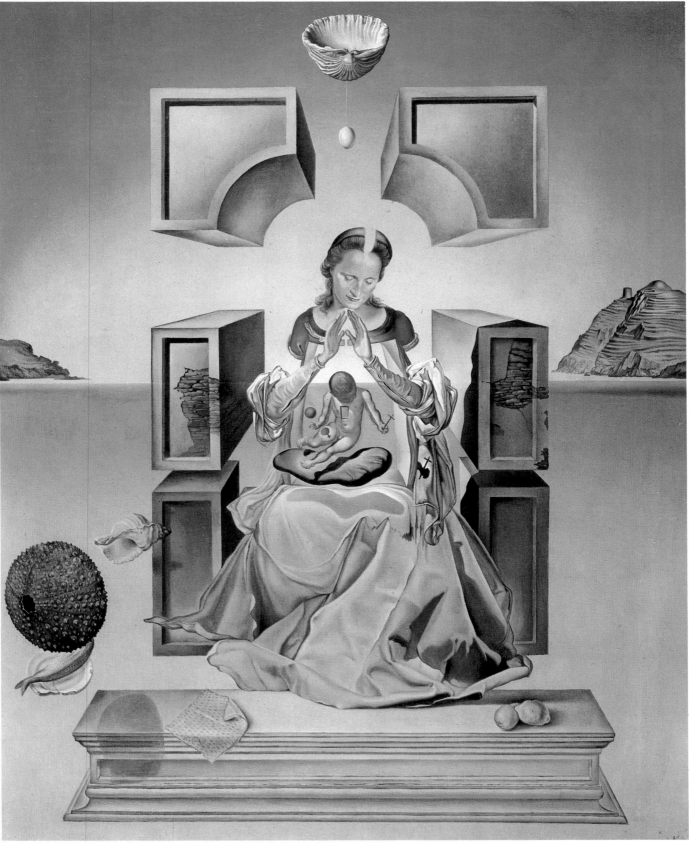



54 Raphaelesque Head Exploding, *1951. Human figures that are also pieces of furniture or architectural interiors are simply a variant of Dalí's double images. Here, a head drawn in the manner of Raphael is also a coffered classical cupola. As it bursts, it produces splinters in the shape of rhinoceros horns. Dalí rendered these horns with a proportional and mathematical perfection that alludes in this context to the virtues of Renaissance architecture and painting.*

55 Christ of Saint John of the Cross, *1951. Dalí's interest in mysticism led him to paint this Crucifixion, which faithfully follows the vision of Saint John of the Cross as described in the commentaries to the* Spiritual Song; *at the same time, it pays obvious homage to the famous painting of Christ by Velázquez.*

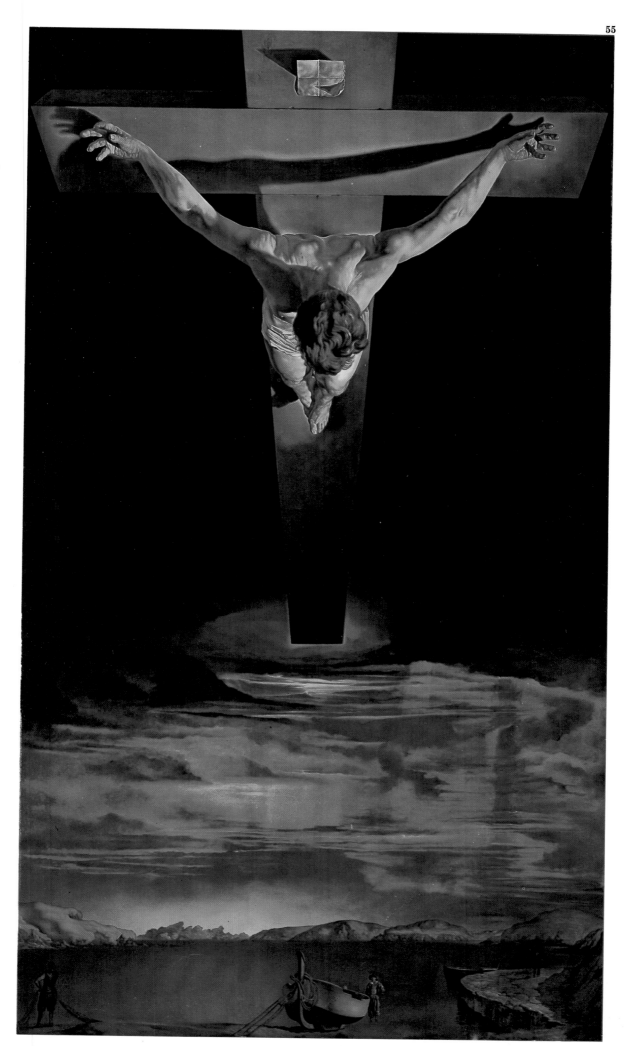

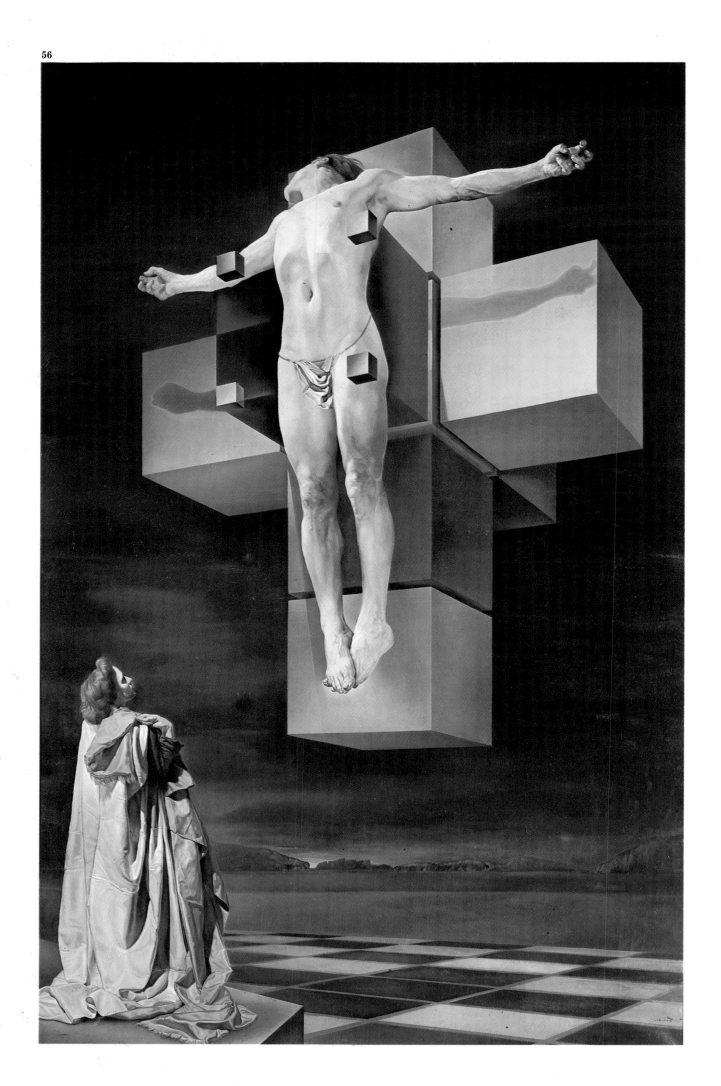

56 Crucifixion (Corpus Hypercubus), *1954. This work combines the influence of the Spanish painter Francisco de Zurbarán with that of the* Treatise of the Cubic Figure, *a textbook of cabalistic geometry written in the sixteenth century by Juan de Herrera, the architect of El Escorial.*

57 The Perpignan Railway Station, *1965. Dalí attached great importance to this picture, composed like a Baroque apotheosis. Once again we see the couple from Millet's* The Angelus.

58 Dalí from the Back Painting Gala from the Back Eternalized by Six Virtual Corneas Provisionally Reflected by Six Real Mirrors *(unfinished stereoscopic picture), 1973–74. The multiplication of space through the mirror refers to* Las Meninas *by* Velázquez *and to* Giovanni Arnolfini and His Bride *by Jan van Eyck.*

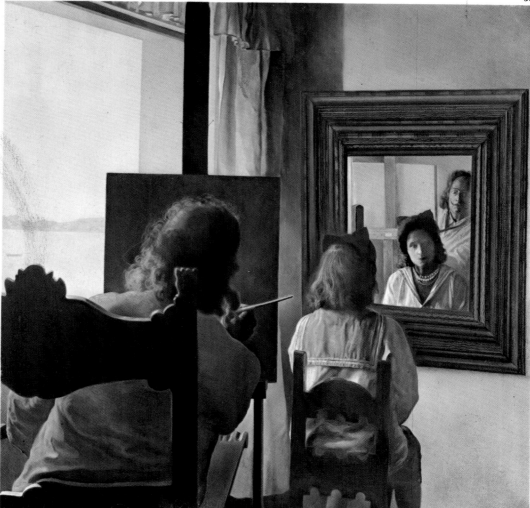

Edible Beauty

In 1933, Dalí published an essay about "the terrifying and edible beauty" of Art Nouveau architecture. Its organic exuberance fascinated him, familiar as he was since his youth with architect-designer Antoni Gaudí's work and that of the Catalan Modernist school, which he described as "an architecture of solidified desires." Following their inspiration, gastronomic metaphors and ideas related to foodstuffs and cannibalism are among the most significant constants of Dalí's thought and iconography. In general, what can be eaten stands for what is mortal; all that we eat is perishable, capable of putrefaction and an anticipation of death. At the same time, what is cooked or eaten undergoes a metamorphosis, transforming the hard into the soft. Thus, eating can be understood as a paranoiac metaphor for knowledge; a way for the subject to incorporate within himself something that is alien to him. Dalí's pictures become peopled with scenes related to nutrition and to his favorite foods —beans, chops, bread, fried eggs—creating a peculiar and hallucinogenic iconography.

59 Gala with Two Lamb Chops Balanced on Her Shoulder, *1933. "I like chops and I like my wife. I don't see any reason not to paint them together," was Dalí's reply to a journalist astonished by this picture. Eight years later, he would paint his own self-portrait with a rasher of grilled bacon.*

60 Cannibalism in Autumn, *1936–37. In one of his works connecting edible objects with death, Dalí invents a macabre banquet incorporating all kinds of culinary utensils, with a place of honor reserved for bread, fruit, and meat. The golden hues of an autumn afternoon serve to soften this violent scene.*

59

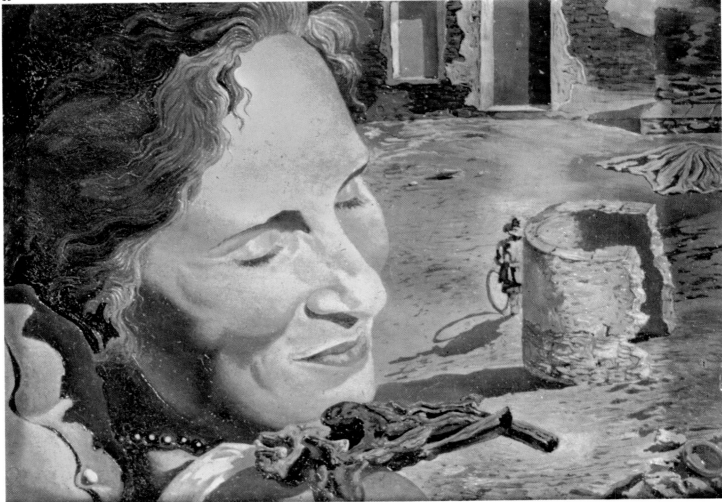

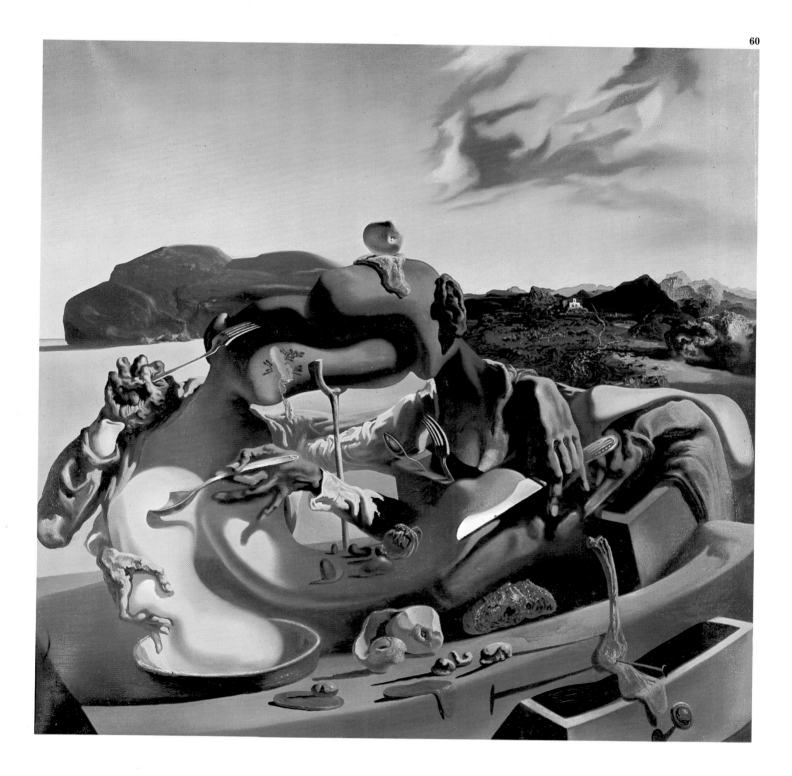

61 Soft Construction with Boiled Beans—Premonition of Civil War, *1936. In this work, the mortal connotation of foodstuffs is more aggressively expressed. This is not a banquet, but quite the contrary—there is no choice of foods. The last resources are within the strangulated body, from which nothing edible can emerge. Dalí thus expresses his tragic and premonitory anguish about the war.*

61

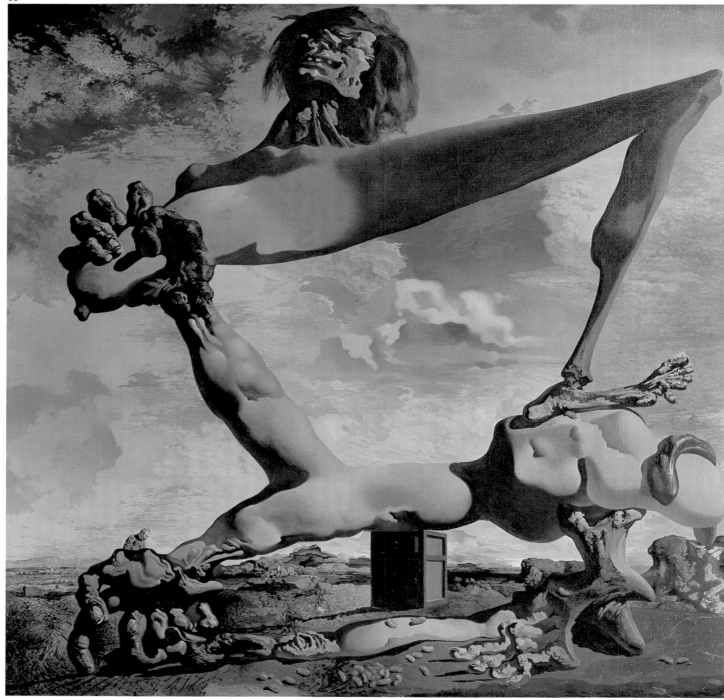

62 Basket of Bread, *1945. Dalí had painted another bread basket in 1926 for his second exhibition at the Galerías Dalmau. Here, the reference to the sober seventeenth-century Spanish still lifes joins the rich symbolism attached to bread, full of mystical and spiritual meanings. Not coincidentally, bread plays a major role at the Teatro-Museo Dalí in Figueras, where a whole wall is covered with locally baked loaves.*

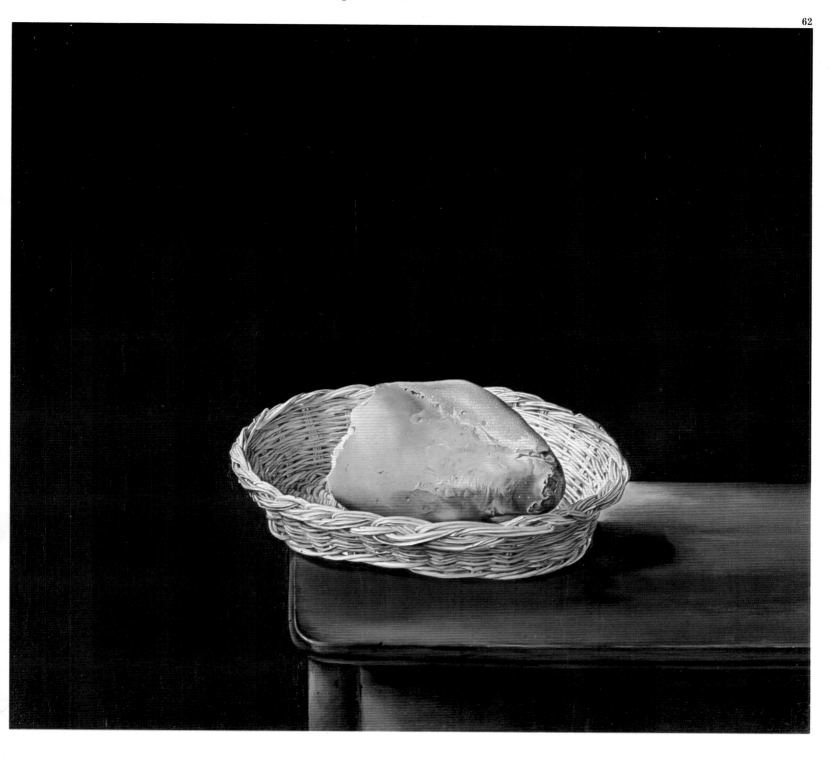

The Drawers of Memory

A very cultivated man, drawn to esoteric books and wide-ranging intellectual pursuits, was hidden behind the eccentric persona that Dalí always represented to the general public. An example was his keen interest in the wheels of memory and other tools related to medieval and Renaissance mnemonics, inspired by the Majorcan sage Raymond Llull or by the *Theater of Memory*, created by the Italian Humanist Giulio Camillo. These figurative analogies, meant to organize the store of knowledge of their time, had great powers of suggestion over Dalí, who translated them into the characteristic furniture/figures that appear in so many paintings throughout his career. However, the major embodiment of these influences is at the Teatro-Museo Dalí in Figueras, which the painter inaugurated in 1974 as a door to his universe and summary of his artistic and intellectual legacy.

63, 64 Burning Giraffes, *1936–37, and* Cosmic Athlete, *1968. The drawers are an allusion to the unconscious or, as explained by Dalí: "The human body, purely Neoplatonic at the time of the Greeks, is today full of secret drawers that can only be opened by psychoanalysis." The architectural metaphor works in a similar way.*

65 The Weaning of Furniture-Nutrition, *1934. The bay of Port Lligat appears inverted as a sign of the visionary character of the subject. The silhouette of the bottle on the piece of furniture evokes a baby bottle; it fits in the hollow area that would correspond to the woman's breasts.*

66 The Anthropomorphic Cabinet, *1936. This work found its primary inspiration in the furniture/figures of the* Capricci, *by the Italian Baroque painter Giovanni Battista Bracelli.*

63

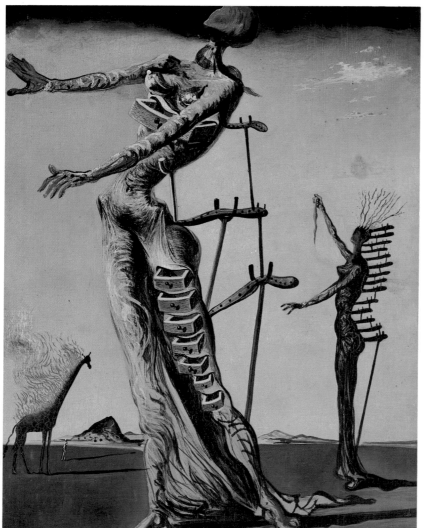

64

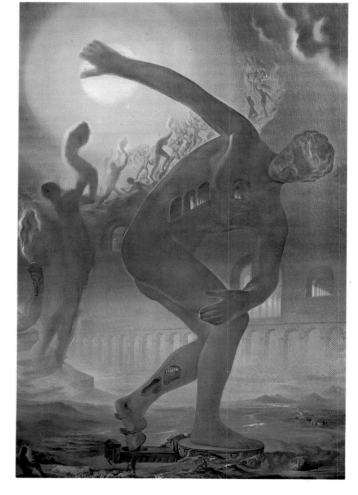

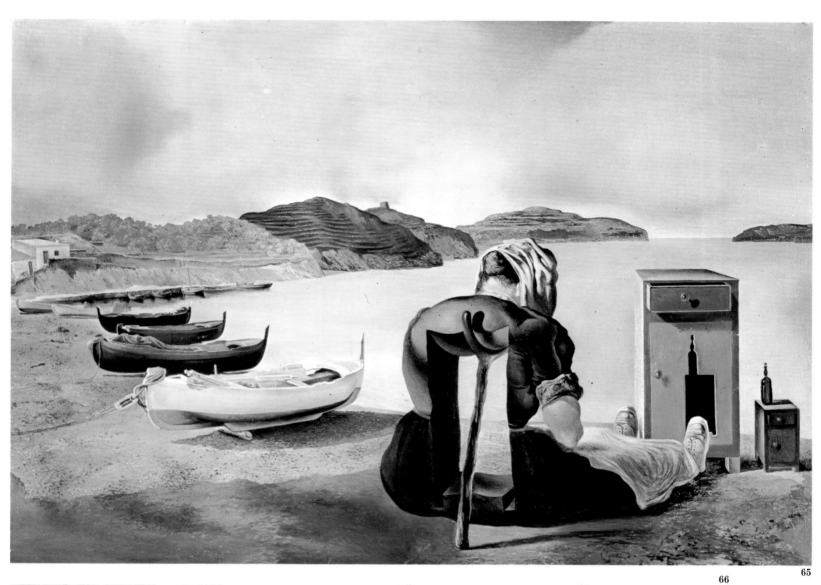

65

66

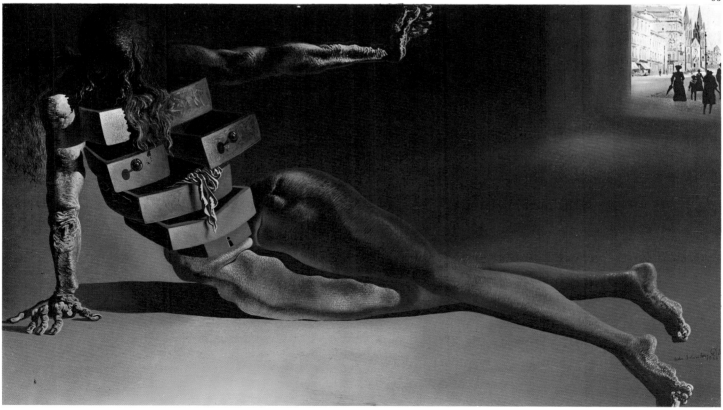

57

67 Spain, *1936–38. In another picture related to the Spanish Civil War, here, the two knights dueling with lances can also be read as a woman's breasts; her head is the double image of a group of people engaged in a violent combat. These war scenes refer to the famous drawings Leonardo da Vinci made for* The Battle of Anghiari. *The red handkerchief hanging from an open drawer is also an obvious tragic metaphor for the war.*

68, 69 Palace of the Winds *(details), 1972–73. These details are from two of the five canvases that adorn the lobby ceiling of the Teatro-Museo Dalí in Figueras. The artist's technique here is similar to that of the great Baroque painters of the late seventeenth century, in its full exploitation of illusionist representation. The two large figures—Gala and Dalí—lead to an imaginary* impluvium *open to the sky.*

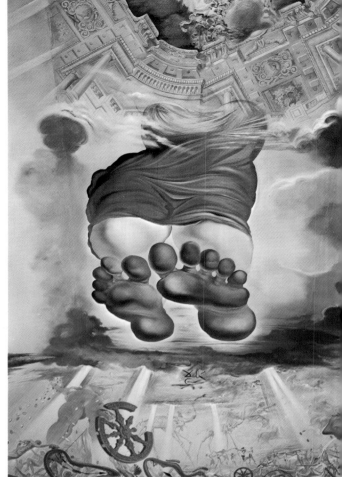

68

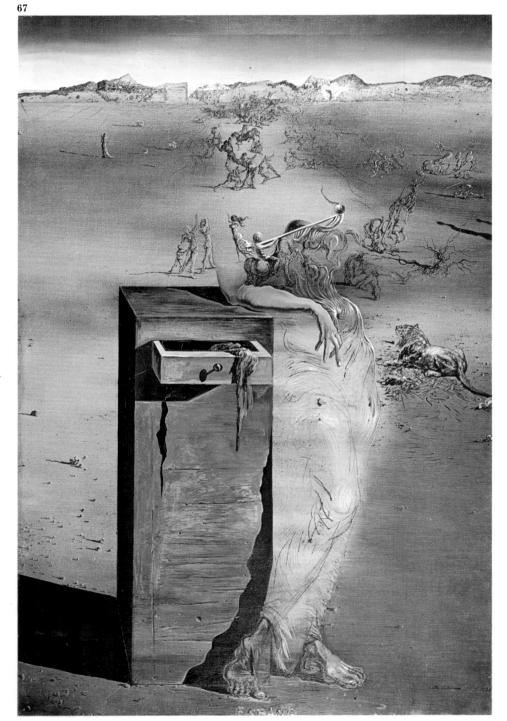

67

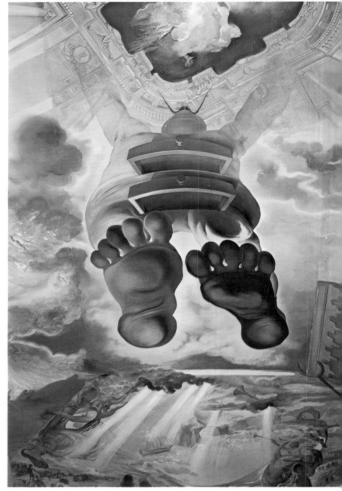

69

Dreams of Science

Throughout the forties and fifties, Dalí displayed an ever-growing curiosity about recent scientific discoveries, especially those related to nuclear physics and molecular biology. Quite a few of his paintings of this period allude to these subjects, some of them created with the help of scientists. Contrary to the satiric or humorous comments on science expressed by certain poets and artists connected with Surrealism—notably, Francis Picabia or Marcel Duchamp—Dalí took science very seriously. Since the atomic structure as well as the DNA spirals imply a reality framework alien to the data we perceive through our senses, they reveal hidden and subjacent realities, like those that emerge in our dreams, hence their affinity with the paranoiac-critical method. Earlier, in the thirties, Dalí had been drawn to Matila Ghyka's research into the golden mean and Pythagorean numerology, also reflecting that interest in some of his paintings. Like Sigmund Freud, father of psychoanalysis, many scientists in other disciplines expressed their respect for Dalí and the rigor with which he depicted their fields in his paintings.

70 The Three Sphinxes of Bikini, *1947. The experimental atomic explosions on the atoll of Bikini, as well as the bombs dropped on Hiroshima and Nagasaki, inspired this Dalí work. Two human heads and a tree become hallucinatory double images of the mushroom cloud produced by a nuclear explosion.*

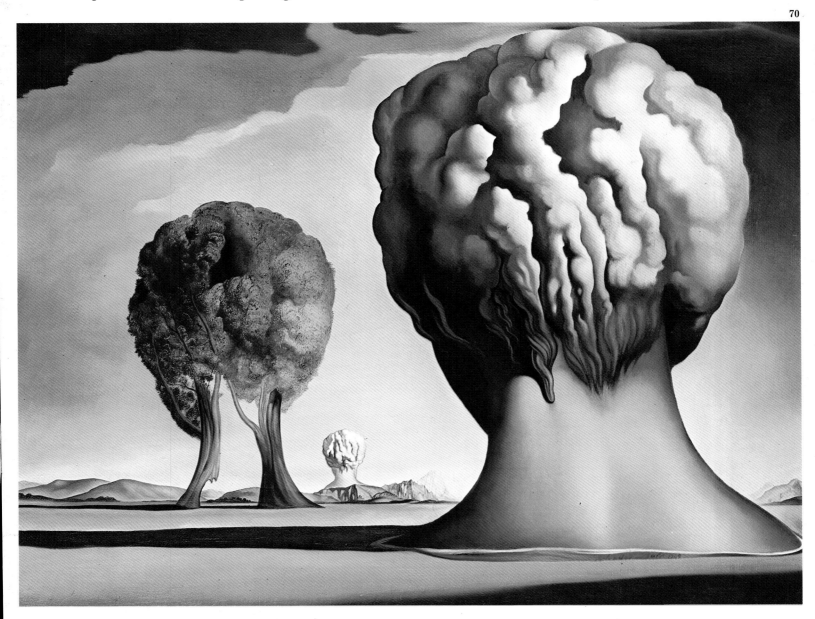

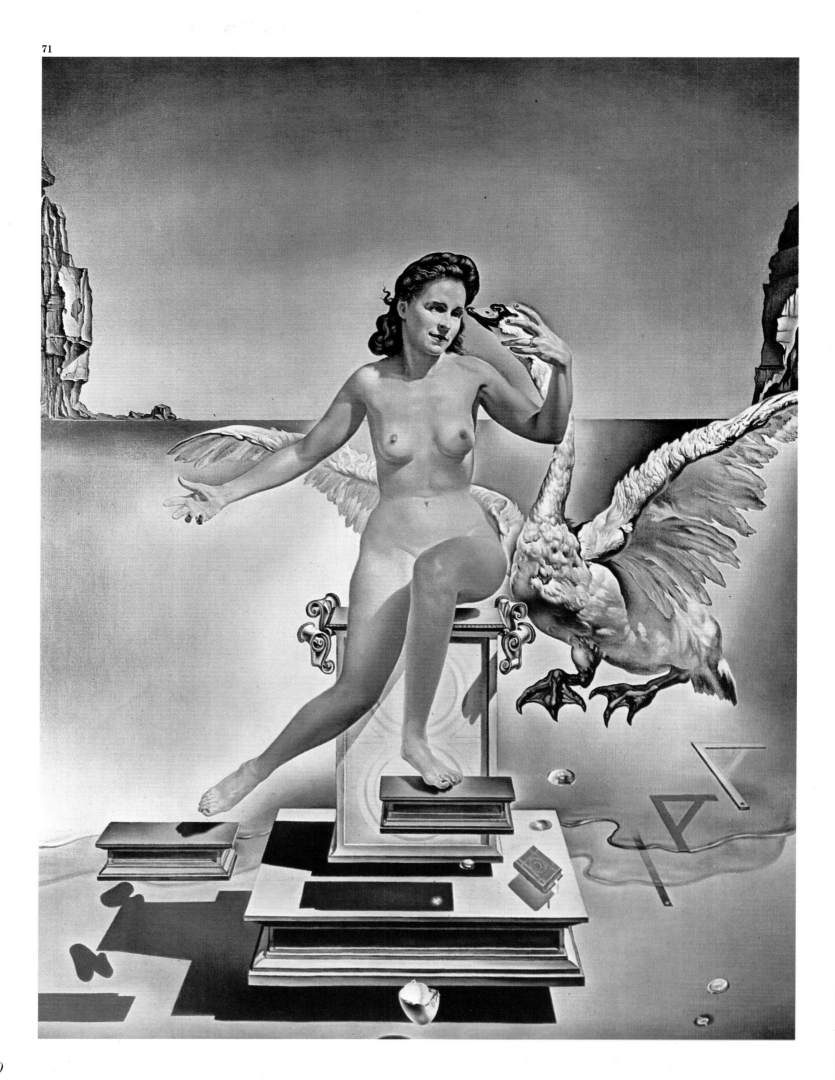

71 Leda Atomica, *1949. The classical fable of the nymph Leda, possessed by Jupiter transformed into a swan, is seen here in the light of nuclear physics. The elements of the picture, like the structure of the atom, gravitate around one another without touching or forming a compact or solid body. The placement of the objects in space was apparently based on guidance given to Dalí by scientist Matila Ghyka.*

72 Galatea of the Spheres, *1952. The previous year, Dalí had written his* Mystical Manifesto, *where he propounded a new component of his universe. This double image of Gala combines the stimuli of spirituality and science, two recurrent obsessions in Dalí's works dated after the Second World War.*

73 Feather Equilibrium, *1947. Various objects that emerge by paranoiac association with a swan's feather appear suspended and under tension, as in the previous picture. They are prisoners of the dynamic equilibrium relating the component particles of the atom to each other.*

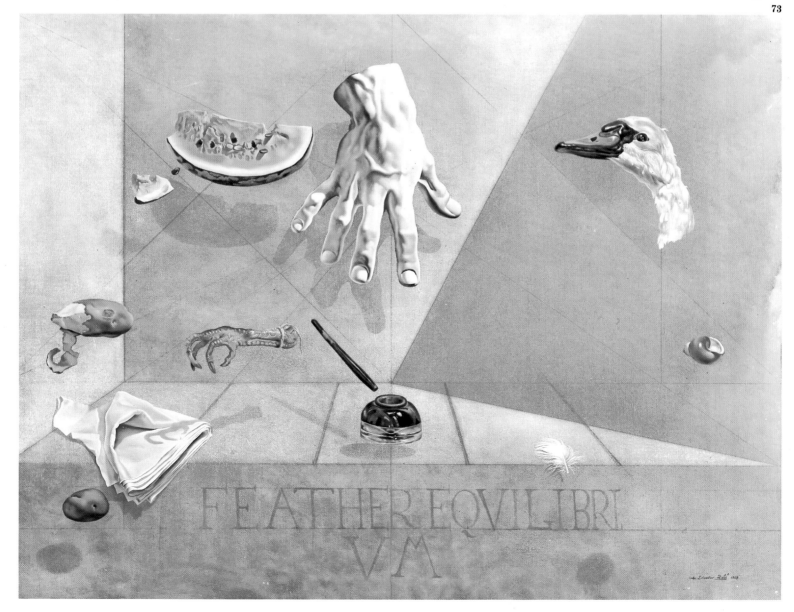

List of Plates

1 Portrait of Grandmother Anna Sewing. *1920. Oil on burlap, 18⅛ × 24⅜" (46 × 62 cm). Collection Dr. Joaquín Vila Moner, Figueras, Spain*

2 Self-Portrait of the Artist at His Easel, Cadaqués. *1919. Oil on canvas, 10⅝ × 8¼" (27 × 21 cm). Salvador Dalí Museum, St. Petersburg, Florida. Foundation Reynold Morse*

3 The Beach at El Llané, at Cadaqués. *1922. Oil on cardboard, 24¾ × 35" (63 × 89 cm). Collection Peter Moore, Paris*

4 Bathers at El Llané. *1923. Oil on cardboard, 28⅜ × 40½" (72 × 103 cm). Collection José Encesa, Barcelona*

5 Self-Portrait with Raphaelesque Neck. *1920–21. Oil on canvas, 21¼ × 22½" (54 × 57 cm). Private collection, Spain*

6 Seated Girl Seen from Behind (Anna Maria). *1925. Oil on canvas, 42½ × 30⅜" (108 × 77 cm). Museo de Arte Contemporáneo, Madrid*

7 Girl Standing at the Window. *1925. Oil on canvas, 40½ × 29⅛" (103 × 74 cm). Museo de Arte Contemporáneo, Madrid*

8 The Girl with Curls. *1926. Oil on plywood, 20⅛ × 15¾" (51 × 40 cm). Salvador Dalí Museum, St. Petersburg, Florida. Foundation Reynold Morse*

9 Cliff (Figure on the Rocks). *1926. Oil on wood panel, 10¼ × 15¾" (26 × 40 cm). Collection Marianna Minota de Gallotti, Milan*

10 Venus with Cupids. *1925. Oil on wood panel, 10¼ × 9" (26 × 23 cm). Private collection*

11 Cubist Self-Portrait. *1926. Gouache and collage, 41⅜ × 29½" (105 × 75 cm). Private collection*

12 Port Alguer. *1924. Oil on canvas, 39⅜ × 39⅜" (100 × 100 cm). Teatro-Museo Dalí, Figueras, Spain*

13 Crystalline Still Life. *1924. Oil on canvas, 39⅜ × 39⅜" (100 × 100 cm). Private collection*

14 Venus and Sailor (Homage to Salvat-Papasseit). *1926. Oil on canvas, 85 × 57⅞" (216 × 147 cm). Gulf American Gallery, Inc., Miami*

15 Barcelona Mannequin. *1927. Oil on wood panel, 78 × 58⅝" (198 × 149 cm). Private collection*

16 Portrait of the Artist's Father. *1925. Oil on canvas, 41⅛ × 41⅛" (104.5 × 104.5 cm). Museo de Arte Moderno, Barcelona*

17 Still Life by Moonlight. *1927. Oil on canvas, 78⅜ × 59" (199 × 150 cm). Private collection*

18 Inaugural Gooseflesh. *1928. Oil on canvas, 29¾ × 24⅝" (75.5 × 62.5 cm). Collection Ramón Pichot Soler, Barcelona*

19 The Endless Enigma. *1938. Oil on canvas, 45⅛ × 57⅝" (114.5 × 146.5 cm). Private collection*

20 The Invisible Man. *1929–33. Oil on canvas, 56¼ × 31⅞" (143 × 81 cm). Private collection*

21 The Great Paranoiac. *1936. Oil on canvas, 24⅜ × 24⅜" (62 × 62 cm). Museum Boymans-van Beuningen, Rotterdam*

22 Metamorphosis of Narcissus. *1937. Oil on canvas, 20 × 30¾" (50.8 × 78.2 cm). The Tate Gallery, London*

23 Impressions of Africa *(detail). 1938. Oil on canvas, 36 × 46¼" (91.5 × 117.5 cm). Museum Boymans-van Beuningen, Rotterdam*

24 Salvador Dalí in the Act of Painting Gala in the Apotheosis of the Dollar, in Which One May Also Perceive to the Left Marcel Duchamp Disguised as Louis XIV, Behind a Curtain in the Style of Vermeer, Which Is But the Invisible Though Monumental Face of the Hermes of Praxiteles. *1965. Oil on canvas, 157½ × 196⅛" (400 × 498 cm). Salvador Dalí Museum, St. Petersburg, Florida. Foundation Reynold Morse*

25 Gala Nude from Behind, Looking in an Invisible Mirror. *1960. Oil on canvas, 16½ × 12⅝" (42 × 32 cm). Teatro-Museo Dalí, Figueras, Spain*

26 Hallucinogenic Toreador. *1969–70. Oil on canvas, 157½ × 118⅛" (400 × 300 cm). Salvador Dalí Museum, St. Petersburg, Florida. Foundation Reynold Morse*

27 The First Days of Spring. *1929. Oil and collage on wood panel, 19½ × 25¼" (49.5 × 64 cm). Private collection*

28 Vertigo, or Tower of Pleasure. *1930. Oil on canvas, 23⅝ × 19⅝" (60 × 50 cm). Private collection*

29 Gradiva Finds the Anthropomorphic Ruins. *1931. Oil on canvas, 25⅝ × 21¼" (65 × 54 cm). Collection Thyssen-Bornemisza, Lugano-Castagnola, Switzerland*

30 Enigmatic Elements in a Landscape. *1934. Oil on wood panel, 24¼ × 23" (61.5 × 58.5 cm). Collection Sulzberger, Paris*

31 Atavistic Vestiges After the Rain. *1934. Oil on canvas, 25⅝ × 21¼" (65 × 54 cm). Perls Galleries, New York*

32 The Horseman of Death. *1935. Oil on canvas, 25⅝ × 20⅞" (65 × 53 cm). Collection F. Petit, Paris*

33 Half a Giant Cup Suspended with an Inexplicable Appendage Five Meters Long. *1944–45. Oil on canvas, 19⅝ × 12¼" (50 × 31 cm). Private collection, Basel*

34 Shades of Night Descending. *1931. Oil on canvas, 24 × 19⅝" (61 × 50 cm). Salvador Dalí Museum, St. Petersburg, Florida. Foundation Reynold Morse*

35 White Calm. *1936. Oil on wood panel, 16⅛ × 13" (41 × 33 cm). Collection Edward F. W. James, Sussex, England*

36 Landscape of Port Lligat. *1950. Oil on canvas, 22⅞ × 30¾" (58 × 78 cm). Salvador Dalí Museum, St. Petersburg, Florida. Foundation Reynold Morse*

37 Agnostic Symbol. *1932. Oil on canvas, 21⅜ × 25⅝" (54.3 × 65.1 cm). Philadelphia Museum of Art*

38 Premature Ossification of a Railway Station. *1930. Oil on canvas, 12⅜ × 10⅝" (31.5 × 27 cm). Private collection.*

39 Masochistic Instrument. *1933–34. Oil on canvas, 24³/₈ × 18¹/₂" (62 × 47 cm). Private collection*

40 Women with Floral Heads Encountering the Skin of a Grand Piano on the Beach. *1936. Oil on canvas, 21¹/₄ × 25⁵/₈" (54 × 65 cm). Salvador Dalí Museum, St. Petersburg, Florida. Foundation Reynold Morse*

41 Soft Self-Portrait with Rasher of Grilled Bacon. *1941. Oil on canvas, 24 × 20" (61 × 50.8 cm). Private collection*

42 Soft Monster in Angelic Landscape. *1977. Oil on canvas, Vatican Museum*

43 In Search of the Fourth Dimension. *1979. Oil on canvas, 48¹/₄ × 96⁷/₈" (122.5 × 246 cm). Private collection*

44 Partial Hallucination. Six Apparitions of Lenin on a Piano. *1931. Oil on canvas, 44⁷/₈ × 57¹/₂" (114 × 146 cm). Musée National d'Art Moderne, Centre Pompidou, Paris*

45 The Specter of Sex-Appeal. *1934. Oil on wood panel, 7¹/₈ × 5¹/₂" (18 × 14 cm). Teatro-Museo Dalí, Figueras, Spain*

46 The Eye of Time. *1941. Brooch-watch in blue enamel with diamonds. The Owen Cheatham Foundation*

47 *Untitled brooch of gold, rubies, and pearls. 1941. The Owen Cheatham Foundation*

48 One Second Before Awakening from a Dream Caused by the Flight of a Bee Around a Pomegranate. *1944. Oil on wood panel, 20¹/₈ × 16¹/₈" (51 × 41 cm). Collection Thyssen-Bornemisza, Lugano-Castagnola, Switzerland*

49 Dalí at the Age of Six, When He Thought He Was a Girl, Lifting the Skin of the Water to See the Dog Sleeping in the Shade of the Sea. *1950. Oil on canvas, 31¹/₂ × 39" (80 × 99 cm). Collection Count François de Vallombreuse, Paris*

50 The Enigma of Hitler. *1937. Oil on canvas, 20¹/₈ × 31¹/₄" (51 × 80 cm). Private collection*

51 Gala and the Angelus of Millet Preceding the Imminent Arrival of the Conical Anamorphoses. *1933. Oil on plywood, 9¹/₂ × 7³/₈" (24 × 18.8 cm). National Gallery of Canada, Ottawa*

52 Millet's Architectural Angelus. *1933. Oil on canvas, 28³/₄ × 23⁵/₈" (73 × 60 cm). Perls Galleries, New York*

53 The Madonna of Port Lligat (first version). *1949. Oil on canvas, 19¹/₄ × 14³/₄" (48.9 × 37.5 cm). Marquette University Committee on the Fine Arts, Milwaukee*

54 Raphaelesque Head Exploding. *1951. Oil on canvas, 17¹/₂ × 13³/₄" (44.5 × 35 cm). Collection Stead H. Stead Ellis, Somerset, England*

55 Christ of Saint John of the Cross. *1951. Oil on canvas, 80³/₄ × 45⁵/₈" (205 × 116 cm). Art Gallery, Glasgow*

56 Crucifixion (Corpus Hypercubus). *1954. Oil on canvas, 6' 4" × 4' ⁷/₈" (194.5 × 124 cm). The Metropolitan Museum of Art, New York. Chester Dale Bequest*

57 The Perpignan Railway Station. *1965. Oil on canvas, 9' 8" × 13' 6" (295 × 406 cm). Ludwig Museum, Cologne*

58 Dalí from the Back Painting Gala from the Back Eternalized by Six Virtual Corneas Provisionally Reflected by Six Real Mirrors (unfinished stereoscopic picture). *1973–74. Oil on canvas, 23⁵/₈ × 23⁵/₈" (60 × 60 cm). Teatro-Museo Dalí, Figueras, Spain*

59 Gala with Two Lamb Chops Balanced on Her Shoulder. *1933. Oil on plywood, 12¹/₄ × 15³/₈" (31 × 39 cm). Teatro-Museo Dalí, Figueras, Spain*

60 Cannibalism in Autumn. *1936–37. Oil on canvas, 25⁵/₈ × 25⁵/₈" (65 × 65 cm). The Tate Gallery, London*

61 Soft Construction with Boiled Beans—Premonition of Civil War. *1936. Oil on canvas, 39³/₈ × 39" (100 × 99 cm). Philadelphia Museum of Art*

62 Basket of Bread. *1945. Oil on wood panel, 13 × 15" (33 × 38 cm). Teatro-Museo Dalí, Figueras, Spain*

63 Burning Giraffes. *1936–37. Oil on wood panel, 13³/₄" × 10⁵/₈" (35 × 27 cm). Kunstmuseum, Basel. Foundation Emmanuel Hoffman*

64 Cosmic Athlete. *1968. Oil on canvas. Zarzuela Palace (Spanish National Trust), Madrid*

65 The Weaning of Furniture-Nutrition. *1934. Oil on wood panel, 7 × 9¹/₂" (18 × 24 cm). Salvador Dalí Museum, St. Petersburg, Florida. Foundation Reynold Morse*

66 The Anthropomorphic Cabinet. *1936. Oil on wood panel, 10 × 17" (25.4 × 43.1 cm). Kunstsammlung Nordrhein-Westfalen, Düsseldorf*

67 Spain. *1936–38. Oil on canvas, 36¹/₈ × 23³/₄" (91.8 × 60.2 cm). Museum Boymans-van Beuningen, Rotterdam*

68, 69 Palace of the Winds (detail). *1972–73. Oil on canvas, in five sections, affixed to lobby ceiling. Teatro-Museo Dalí, Figueras, Spain*

70 The Three Sphinxes of Bikini. *1947. Oil on canvas, 11³/₄ × 19⁵/₈" (30 × 50 cm). Galerie Petit, Paris*

71 Leda Atomica. *1949. Oil on canvas, 23⁵/₈ × 17⁵/₈" (60 × 44 cm). Teatro-Museo Dalí, Figueras, Spain*

72 Galatea of the Spheres. *1952. Oil on canvas, 25¹/₄ × 21¹/₄" (64 × 54 cm). Teatro-Museo Dalí, Figueras, Spain*

73 Feather Equilibrium. *1947. Oil on canvas, 30¹/₂ × 38" (77.5 × 96.5 cm). Private collection*

Editor, English-language edition: Robbie Capp
Designer, English-language edition: Judith Michael

Page 1 Portrait of Freud. *Illustration for "The Secret Life of Salvador Dalí."*
Ink on paper. Private collection

Library of Congress Catalog Card Number: 94–79671
ISBN 0–8109–4679–3

Printed and bound in Spain by La Polígrafa, S.L.
Parets del Vallès (Barcelona)
Dep. Leg.: B. 1.891–1995